HAUNTED
BRECKENRIDGE

GAIL WESTWOOD

Haunted
America

Published by Haunted America
A Division of The History Press
Charleston, SC 29403
www.historypress.net

First published 2015

Manufactured in the United States

ISBN 978.1.62619.830.2

Library of Congress Control Number: 2015941434

CONTENTS

CONTENTS

PREFACE

L ong before the first prospectors found gold in the mountains and rivers of Summit County, Colorado, the area was occupied by far more unusual occupants. The first evidence uncovered was the remains of a tusk that belonged to a mastodon, a prehistoric animal that looked like a cross between an elephant and a mammoth. They had longer bodies and shorter legs than the mammoth, with long, curved tusks. These animals roamed North America more than ten thousand years ago and eventually became extinct. When this discovery was made by a couple of Breckenridge prospectors in 1861, their interests were not in archaeology but in digging a ditch to supply water to aid their efforts to find gold. Luckily, the local judge was more excited about the find and sent it in to the *Rocky Mountain News* in Denver, where it was more appreciated.

Another accidental discovery was made later in that decade by another miner. While searching for gold in the foothills near Breckenridge, he uncovered a skeleton that had turned to stone. It was an unusually large seven-foot-tall man. He was found surrounded by hefty and dangerous war weapons. This story was reported in Summit County's first ever newspaper, the *Summit County Times* (but was never followed up).

The peace-loving Ute Indians were the first people that researchers know for certain inhabited this valley as far back as 6,500 years ago. They were a nomadic people who were attracted to the beautiful Blue River valley and made it their summer hunting ground. They called it by the name of *Nah-oon-kara*. Although there is no official translation into English, it is believed that it refers to the "river of blue that rises from the ground."

Around two hundred years ago, what is now Summit County seemed to be created for the hunter. Animals of all kinds roamed this area in vast numbers. No sooner had a man raised his rifle than a bear, elk, buffalo, deer, beaver, sheep or rabbit would pop into sight. This, of course, was also the attraction for the next group of people who invaded the area—trappers.

Starting with Ezekiel Williams, the first known explorer to make his way to Colorado to hunt in 1811, explorers from all different backgrounds followed in large numbers. Although the variety of wildlife was immense, they set their eyes on the biggest prize. They believed that one animal in particular was going to make their fortunes. To wear a beaver hat in the early 1800s was the height of fashion, and this item also kept men warm in cold temperatures. These trappers lived peacefully with the Utes but didn't welcome the gold seekers who might interfere with their hunting activity. These men were very good at keeping a secret, though. They knew all about the gold that was sitting in the rivers around here but weren't prepared to share that information with the gold diggers and have them scare all the animals away!

Thirty years after the start of the beaver craze, a new fashion took over in hats—silk. That wasn't a material that was available to them, so in time the trappers took off to find a different way of making a living.

That left the way clear for the gold hunters to overrun the hills and valleys of Blue River, and that's exactly what they did. Explorers like Major Zebulon Pike and Colonel Fremont made people more aware of the West, but it was the financial panic in the East in 1857 that caused an influx of men to search for a new way of making their fortunes after losing everything they owned in the crash.

Twenty years after the first gold boom in 1859, silver was added to the riches to be mined, and towns like Breckenridge, Frisco and Montezuma moved into a different phase. Respectability took over in 1880 and the towns were built to display the wealth that now existed. To add to the mix of miners, prostitutes and merchants who had only come here to "mine the miners" (i.e., to charge exorbitant prices for basic mining equipment and other services), there were now Victorian ladies and gentlemen arriving in town. Instead of crudely built log cabins, they constructed elegant homes for themselves whose walls were lined with wallpaper and in which they entertained one another with society meetings, dinner parties and polite card games such as euchre and whist. They had printed calling cards that they left on one another's silver platters when the host was away from home. They built churches to worship in and halls for formal dances, and they

frowned upon the rough-and-ready men and women who had established the town. They sought to rid the town of establishments such as the saloons and were inspired by the teachings of the Temperance Society.

Mining lasted eighty-three years in total, and when it was over, the surrounding land of Summit County was destroyed. The Utes would not have believed their eyes if they had returned in the late 1940s to see the devastation that the miners had caused and left behind without any attempt at cleaning up. There were rock piles where there used to be a river, the hillsides were eroded from the hydraulic mining and the mountains were riddled with spoil heaps and holes in the ground that resembled the surface of the moon.

After a brief period of inactivity in which Breckenridge almost became a ghost town through lack of industry, a new "gold" took over in 1961 and made new fortunes for a different kind of prospector. Skiing became the new industry and changed the face of the hillsides forever.

It is no wonder that the spirits of these former inhabitants roam the local area and the homes in which they used to reside.

ACKNOWLEDGEMENTS

Thanks to The History Press for giving me the opportunity to write my first book. I would especially like to thank Stephanie Waters of Blue Moon Haunted History tours of Manitou Springs without whose inspiration this book would never, ever have been written! Thanks also to my daughter Holly for her invaluable help as photographer and critic.

This book would not have been possible without help from the following people: Maureen Nicholls, Karen Musolf, Mary Ellen Gilliland, Susan Gilmore, Susan Donaldson, Jan Thomas and Robin Theobald. Thanks also to the following publications: *Summit County Journal*, *Summit Daily News*, *Denver Post* and the *Fairplay Flume*.

The following books were invaluable for research: *Blasted Beloved Breckenridge*, by Mark Fiester; *Summit*, by Mary Ellen Gilliland; *Summit Courthouse*, by Susan Donaldson; *My Breckenridge*, by Raymond McGinnis; *Rascals, Scoundrels and No Goods*, by Mary Ellen Gilliland; *Behind Swinging Doors*, by Sandie Mather; *Breckenridge: 150 Years of Golden History*, by Mary Ellen Gilliland; *The Soul Collector*, by Joni Mayhan; and *Ghost Hunter*, by Hans Holzer.

Thanks to the many people who answered all my annoying questions: Jan and Scott Magnuson; Steve and Sheila Jeggentenfl; Monique from Amazing Grace; Betsy Tomlinson from Country Boy Mine; Donna, Bill and Shela from Apres; Alex Lamarca; Gene, Tom and AnnaDane Dayton; Rick Bly; Mike Cavanaugh; Reggie Gray; Jan Butler; Stu Van Anderson; Ben and Martha Little; Eric Degerberg; Nikki Harris; Lauren Lewsadder; Jennifer, Kim and Leanna from 235 South Ridge Street; all

ACKNOWLEDGEMENTS

the girls at the Dredge Restaurant; Mary Ellen; Kerry; Kevin O'Handley; Debbie from Angel's Hollow; T.S. Messerschmitt; Jane Tarlow; Stephanie Capitina; Susan and Win Lockwood; Megan; Jake; my dear English friend; and the Breckenridge Heritage Alliance.

BRECKENRIDGE'S CEMETERIES

THE MINERS WHO COULDN'T RIP

In 1859, when the first miners made their way to Breckenridge to follow the gold rush, the only form of burial was a primitive, shallow grave dug at the site of death with a wooden headstone with the miner's name carved out. This method worked for some time, but after a few years, there were thousands of miners in the area, and the men realized they needed a more formal burial ground. Approximately five acres of land was designated at the south end of town. Peace and tranquility for these poor miners lasted for a few years—until a miner who was working in that area struck gold and told his fellow miners that they needed to move all the bodies out of the way to get at the rest of the gold.

A piece of land at the north end of town was chosen as the site of the new cemetery, and all remains were moved here. The idyllic Valley Brook Cemetery was established in 1889. It was laid out in the Victorian fashion, with avenues having names such as Marsh Marigold Street and Sage Buttercup Street. Those who could afford it had ornate, wrought-iron fencing around their graves. Around this time, Breckenridge experienced one of its worst epidemics of diphtheria. This disease was extremely contagious and quickly spread through the town, taking with it many of the children of that period. To those of you who are not familiar with this disease, the most common signs of diphtheria are as follows. The first day will give the sensation of a sore throat, followed by a feeling of constriction. On the second day, upon looking in a mirror, the sufferer will notice a grey coating appearing on the back of the throat and may see that the neck is starting to swell. The last

stage has the coating turning black and the throat closing up entirely. This agonizing process takes, on average, four days before death ensues.

There were two young local girls at that time, Annie Fletcher and Helen Remine, who were the closest of friends. Annie was nine years old and was part of the pioneer Fletcher family. Helen was a little older and also from a well-known local family. These girls were inseparable and never did anything apart. Unfortunately, Annie soon contracted diphtheria and became very sick. Helen sat at her bedside day and night. On her last evening, lying on her deathbed, Annie uttered her last few words, "Come, Helen, come. Helen, please come!" She reached out her hand to beckon her friend but died shortly after. Helen was grief-stricken, as she had never known life without Annie at her side. Feeling bewildered, lost and alone, the prospect of joining Annie and fulfilling her last request was too enticing for Helen to resist. Within a few hours, a heartbroken Helen followed Annie into death, despite the fact that she never caught the disease herself. If it is possible to will someone to die with you and join you in the afterlife, then that is exactly what happened that night.

In 1904, the town of Breckenridge decided to have a cleanup at Valley Brook, and an advertisement was put in the local paper to locate the bodies that officials knew might still be buried in and around the town. For information leading to the discovery of a body, one would receive a reward of one dollar. When residents came forward with information, the town moved what remains there were to the new cemetery. Some remains were even found in the original cemetery, lying in unmarked graves. All remains that were found were buried together in one deep pit, and a headstone was erected with one word: "Pioneers."

By 1997, the land that was once the site of the old cemetery was owned by locals Jim and Maureen Nicholls, and they were approached to sell it. A developer was interested in building condominiums on what he considered to be a perfect site. The land was sold, and excavation began. One of the first things uncovered was a small headstone that read "Daughter of W.F. and M. Eberlein, Infant, born and died April 6, 1879." Research was carried out, and it was found that the rest of the Eberlein family was buried at Valley Brook. Maureen Nicholls decided to have a recommittal service for the baby and arranged for a white casket to be made. In Victorian times, a white casket was the trend for a child's burial, and the pallbearers were usually children, also dressed in white. A horse and carriage was hired, and accompanied by several of her friends (some of whom were dressed in Victorian costume), Maureen marched the two miles from the original site to Valley Brook where

a recommittal service took place, followed by a "wake" at a local historical bar. Baby Eberlein was finally reunited with her family after more than one hundred years in what was a very touching ceremony.

This event took place on October 25, 1997. Six days later, it was Halloween, and Breckenridge had one of its worst storms ever. Winds of over one hundred miles per hour stormed through the county and caused havoc at Valley Brook. Over eight hundred trees came down that evening, numerous headstones were knocked over and fencing was damaged. The Victorian grave site of a local surveyor, Charles Walker, was severely damaged—in particular, the wrought-iron fencing that encased the tombstone. It was so badly damaged that the town of Breckenridge had to remove it and take it to a specialist forging company near Denver to be repaired. A father and son ran this business, and as the son had just finished serving his apprenticeship, he was given the job of repairing the fencing surrounding the tombstone. His father left him in the basement, where their workshop was located, and told him to take his time. The father returned upstairs, but within minutes, he heard his son cry out in shock, and so he went back downstairs to find out what had happened. The son told his father that he had picked up his hammer and hit the fencing just once, but when he looked down, he saw that the fencing was completely restored. The father turned to his son and said, "That would explain the black shadow that just crossed me as I came down the stairs to see you." Charles Walker, we assume, was satisfied with the work and from then on rested in peace.

However, things did not go so smoothly for the developers at the site of the original cemetery. In 1999, after two years of construction, the luxury condominiums were finished and ready to sell. What most people (other than locals) did not realize was that a number of buckets filled with bones had been brought out of the ground. In some cases, it might be a skull that was found, or it might be a leg bone, but complete skeletons were never found. Initially, the remains were moved to Valley Brook and discreetly interred in the "Pioneers" grave. This was always done at night to avoid any newspaper reporters getting hold of the story, but after finding too many small bones, the developer decided that it would be less work and probably more respectful to leave them in the place where they were found.

Soon after, the condos were all sold, and owners moved into their long-awaited homes. As it happened, problems started soon after people moved in. First, cracks started appearing in the ceilings, and then there were cracks in the walls. The plumbing would not work, and in some units, water ran down the walls, and there was an epidemic of faulty wiring that could not

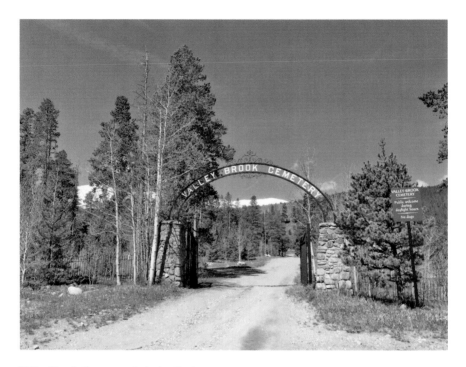

Valley Brook Cemetery. *Author's collection.*

be repaired. Owners moved out while repairs were done and moved back in once they were completed, but less than ten years later, the whole building had to be evacuated. Not only was the roof unstable and in need of replacement, but the foundations were also suffering badly, and the entire property was sinking into the ground. We can only assume that some of the original occupants of the land were not happy about a block of condominiums being built over their resting place.

Coincidentally, the developer ended up bankrupt and had bad luck follow him and his family until he was forced to leave the area. The condos are still standing today, but the author has spoken to several contractors who are still called in to repair unusual damage on a regular basis.

CHAPTER 1
THE LADIES' STORIES

KATIE BRIGGLE: BRECKENRIDGE'S LEADING LADY

In 1896, Kathleen Briggle arrived in Breckenridge from Ohio. Katie, as she was best known, was a dark-haired Irish girl, born in Canada to immigrants from Ireland. She left her home and moved to the United States, where she met her future husband, William Briggle, from Canton, Ohio. William moved the newly married couple to Breckenridge at the request of his brother-in-law, George Engle, to manage the bank Engle had just founded, the Engle Exchange Bank. Katie was a talented musician and spent her time teaching local children to play the piano, organ and other instruments and organized social events for local sectors of the Eastern Star, the Breckenridge Musical and Dramatic Society and for church socials.

When Katie and William first arrived, they lived in a modest log cabin on the east side of town but soon enlarged the cabin extensively and created a luxurious home suitable for entertaining, which included a music room, parlor and dining room. This was one of the finest homes in Summit County at a time when most residents lived in one-room cabins. Katie liked the finer things in life, and everything she needed was either bought in Denver or ordered by catalogue and transported to Breckenridge by train. Her walnut piano, inlaid with ebony, was a birthday gift from William and had her initials engraved on it. It was the finest that money could buy and would have cost him around $1,200 back then. She set the precedent for etiquette

in this town, and all other ladies followed. Her musical evenings were the talk of the county, and she often entertained sixty people in her home at one time. If it wasn't a musical evening, it might have been a card game of euchre or bridge.

Katie's dinner parties were renowned in the area, and what she served at the table, how she decorated the house and what the ladies wore were all reported in the personal column of the newspaper the following day. We think of Facebook as a new phenomenon of social communication, but the Victorians were way ahead of us!

Breckenridge grew into a very respectable Victorian town by the turn of the century, and Katie became its leading lady. However, Breckenridge was born out of a gold rush and depended on its minerals to keep the town thriving. Within four decades, placer and hydraulic mining had ceased, and the last gold dredge boat was forced to stop working in October 1942 when the War Board dictated that there was to be no more mining. All hands were needed for the war effort.

Local records do not indicate when Katie left the town, but we do know that, sadly, William had died of a heart attack in 1924, so it is likely that she left soon after that. At first, she spent a month or two away from Breckenridge. Sometimes she went to Denver to visit her sister, but for a longer trip, it was usually California. Her social life would not have been the same in Summit County without her husband.

The ghost tour of Breckenridge started in 2010. It is a walking tour of haunted downtown and tells stories of the spirits that are found there. When it first began to go into the Briggle House two years later, the house was not open to the public. Several years prior to that, when operated by the Summit Historical Society, the Briggle house had been manned on a regular basis as a museum. Visiting the house, you would find it set out exactly the way it was during Katie's time. For example, in the parlor there was a piano, an organ and other instruments, together with a chaise longue and other pieces of period furniture. However, stories emerged of it being visited by the ghost of Katie Briggle. Guides who worked in the building reported feeling cold drafts blowing past them and doors opening and closing by themselves. Safe to say, it was not the most popular docent job.

One of the first documented incidents that occurred in the house involving Katie was a report from people who were taking a historic walking tour of town and were taken through the Briggle residence to get a feel for domestic life at the turn of the century. The tour group included among its guests a psychic, a fact that was unknown to the guide of the group at

the beginning of the tour. Despite the fact that this tour took place during the day, the psychic, Elaine, was unwilling to enter the bedroom belonging to Katie and William. Elaine reported that Katie was actually present in the room at that time. Elaine fully described the deceased Katie in her Victorian outfit and then told the guide that Katie made it known to her that the tour was not welcome in the bedroom. The tour moved out into another room, but Katie followed, hovering around the group. The guide thought this was a unique opportunity to ask Elaine a few questions about Katie and find out more about her as the former owner of the house. She told Elaine about her plans to create a living history tour as Katie Briggle and asked what the reaction was to that idea. Katie replied through the psychic that she would be delighted to have the tour created about her. Katie was asked whether she minded people walking through her house, and she responded that she did not mind as long as the groups were respectful. The next question concerned the year represented by the tour, and when asked if 1910 might be appropriate, Katie vehemently replied that it was not suitable. This encouraged the guide to carry out extensive research to find out what bad fortune had befallen the town of Breckenridge during that year that would have so upset Katie, but even after several attempts, she could not find anything. After one last try at solving this puzzle, she was able to find an obscure article in the local newspaper about a fire that had occurred in the Briggle house in March 1910. The fire had not only burned Katie's prized ebony piano, one of her many prized possessions, but it also nearly razed the house. In fact, the only room left intact was the dining room, which was Katie's favorite room, and if this had been reduced to ashes, she would have abandoned the house. As it was, this room was unharmed. This article was unknown to the locals of present day and came as a surprise. Now the guide had her answer—Katie would not have wished to be reminded of that disastrous year.

Several months after the above incident took place, there was a second startling encounter with Katie. During another daily walking tour given by the same tour guide, Katie made her presence known to the guide while she was in the pantry. This small room was set up the way it would have looked at the turn of the century, and cans of fruit and vegetables filled the shelves. Upon entering that room, the guide was startled when she witnessed one of the cans fly off the shelf, up into the air and then crash down at her feet, narrowly missing her head. One of the guests on the tour observed that it was a deliberate act. The guide admitted that nothing like this had happened before but thought she might know the cause.

A few days before, she had given one of her living history tours as Katie Briggle and, as usual, had served tea and cake in the dining room. Normally, she would have cleaned all the cups and plates and put them away, but on this occasion, she had to leave the house in a hurry and left the dirty dishes on the table. She planned on returning the next day to clear up but was not able to do so. She realized that Katie was extremely annoyed at having had her kitchen left in such a mess and wanted to make sure the guide was aware of her displeasure.

Other events have taken place, including a cake tier, which always sat in the center of the dining table, appearing in the middle of Katie's bed one day. Just before a tea tour was to commence on another day, it was found that one of the teacups, turned over in its saucer, held the broken shell pieces from a bird's egg. The guide herself had placed the upturned cup in the saucer just hours earlier and knew that there was nothing underneath it then. During a ghost tour on another occasion, Katie was observed by a psychic sitting on the chaise longue in the parlor. She was drinking a cup of tea.

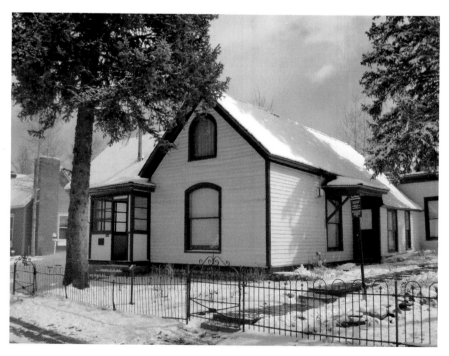

Briggle House on Harris Street, 2015. *Author's collection.*

On a date close to Halloween in October 2012, paranormal investigators were invited into the house to conduct an investigation. During the day, a psychic was also invited there and told the group that Katie was actually entertaining guests at that moment. Katie informed the psychic that she was agitated about the investigators being there and wanted them to leave immediately. That evening, all the usual equipment, including EVP and EMF recorders, as well as white noise detectors and flashlights, were used. The investigators had the greatest success in the bedroom and made contact with the spirit of Katie using the above tools.

Until 2012, it was not known where Katie had been buried after she left Breckenridge, or even what year she had died. The same guide searched the records and, with the help of a fellow guide, was finally able to locate Katie resting in Crown Hill cemetery in Wheat Ridge, Colorado. After visiting the grave site, the guide found that Katie had died in a Denver hospital in 1946. From there, the guide found the obituaries in the Denver newspapers and discovered that Katie had moved to Denver to be with her sister and finished out her final years in the city. She had also been an invalid for the last ten years of her life following a bad fall, so her time in Denver was not a happy one.

The guide concluded that the happiest years of Katie's life were spent in her Breckenridge home and that was the reason for her continued visits, where she can carry on entertaining her friends and anyone else who happens to drop by.

MINNIE THOMAS: THE PLAYFUL GHOST

The personal column of the local newspapers around 1900 would have told you everything you needed to know about what was happening in town. It gave a full report of the whereabouts of each local and visitor, reporting on his or her train or car rides to Leadville, Denver or farther afield. The paper reported on who was visiting and why, and even reported details of each guest's attendance at a social gathering.

Some well-known characters of Breckenridge's past are remembered simply for being outstanding citizens in a time when every resident knew one another. Minnie Dusing Thomas was one such resident. She came to live in Breckenridge with her family when she was six years old and remained there for the rest of her life. During the winter of 1913, she

visited her married sister Lizzie one night. Her sister lived in Frisco, and the only way to get there was by sleigh. Minnie joined a group that was going to attend a dance given at the Frisco Hotel, and there she met her future husband, Bill Thomas, who owned a successful dairy ranch near Frisco. They were married shortly after on December 24, 1913, and lived on Bill's ranch, a 145-acre ranch that had been left to him by his mother. It may have been the size of the ranch or the hard work that Minnie was unaccustomed to, but the marriage wasn't a huge success. Minnie wasn't inclined to be a homemaker or a ranch hand, and perhaps another reason she struggled in the marriage was that it took her away from her two passions: hiking and skiing. The failure of the marriage might also be due in part to the fact that Bill was a heavy drinker and often came home drunk in the early hours of morning. There are many stories of Bill taking all night to return back home to the ranch after he had been at the bars of Frisco's Main Street, just a few blocks away. Although he was a very popular figure in Frisco, he was also considered a little eccentric, going so far as to think that Minnie's underwear would make great insulation for the chinking in their cabin. It didn't matter whether she had finished with the item or not; he would go right ahead and steal it out of her drawers.

They started to lead separate lives and were divorced several years later. This was quite a rare occurrence in Summit County in the days when women stayed in marriages just for the security of having a roof over their heads. Minnie returned to Breckenridge, to the cabin she had lived in with her mother when she was a girl, and lived there for the last chapter of her life, hiking in the summer with her camera to capture the wildflowers and animals that she admired and, in the winter, skiing her way around Summit County. Minnie was really ahead of her time and would have fit in with today's lifestyle without anyone batting an eye.

In the late 1960s, Minnie went out of the cabin to visit the outhouse in the yard one day, as she had never had indoor plumbing installed at the cabin. Unfortunately, she slipped on the ice, breaking her hip. From then on, she was moved to a rest home for the elderly in the picturesque Twin Lakes area. After she had become too infirm for the owners of the rest home, they moved her into a nursing home in Leadville, where she passed away in 1970. All her belongings were handed over to local friends, including a huge collection of postcards, photos and memorabilia.

An inviting gift shop now resides in Minnie's cabin at 202 South Main Street. It specializes in carved wooden statues, mostly animal figures. The shop is called Creatures Great and Small and was started by Jan and Scott

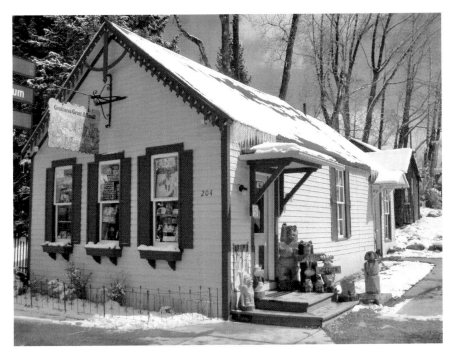

Minnie Thomas's home on Main Street, currently Creatures Great and Small. *Author's collection.*

Magnuson in 1986. When they first moved in and started their business, they felt Minnie's presence immediately. First, they were aware of the sound of footsteps coming from the attic, a tiny room used for storage in the rear of the store. In Minnie's day, her prized collection of photographs and postcards was kept up there, and not surprisingly, the other noise they heard resembled the sound of someone rifling through a box, desperately looking for a lost item. They always knew where Minnie was by following the trace of an old-fashioned scent that smelled like roses. When plates started flying off the wall but not breaking, the Magnusons were not surprised and assumed it was Minnie passing on her displeasure at having someone take over her home—a common occurrence for spirits who are unsure or displeased by new tenants of their home. The couple hung wind chimes from the ceiling in the store hoping to attract customers, only to have them spin frantically around and crash to the ground unexpectedly.

It is Jan and Scott's custom to use a doorbell to alert each other in case one of them gets caught in the store with an influx of customers. The doorbell is attached to the wall at the back of the shop and rings in the

attic storage when one of them is up there getting new stock. The bell frequently rings from downstairs when Scott is by himself in the building. As you can guess, when Scott rushes down to assist, the shop is empty. Minnie, it seems, has a sense of humor.

In the summer of 2014, a family of four walked into the shop one day. While the parents were distracted at the rear of the shop, their two small children were crouched down on the floor looking at and picking up the carved wooden animals on display at the front. Suddenly, the children jumped up as a large metal cross that had hung on the wall above them flew off from its hook and landed on the floor between them. It had been hanging there for years, securely attached to a large hook. The children were startled, but no harm was done. Could it have been Minnie warning them that it's fine to look at the display but not to touch? This event was recorded on a security camera, which I was able to watch the following day.

A psychic who recently visited the store with me remarked that Minnie was a playful character and said she was aware that Minnie was present that day. She saw her watching us curiously, especially in the storage space upstairs. When we moved from there to the rear of the shop, she followed. At this point, a man in hobnailed boots joined Minnie, and the smell of beer was obvious. Had her ex-husband Bill come to visit her—or maybe taunt her?

When they first took over the cabin, Jan disclosed to me that she felt uncomfortable in the building, but as the years wore on, that feeling disappeared. Jan is now convinced that Minnie just wants to remind them of her presence, and the incidents that still occur today give evidence of that.

Bertha Welch: A Wasted Love

Lying in the tranquil setting of Valley Brook Cemetery is Bertha Welch, who has one of the few original wooden headstones that has survived from the turn of the last century. Looking at the simple headboard you wouldn't have any idea that her story was such a tragic one.

Bertha Cravath was born in San Diego, California, on June 9, 1882. She had a happy, innocent childhood, living with a close and devoted family. As a young lady, she met a soldier named James Welch, who came from Canada. They met in San Diego, where he was working as a conductor on a trolley bus, and she was instantly attracted to him. The relationship developed into

love, for her anyway, and he easily won her heart. However, her father didn't approve of the former soldier, and the rest of the family joined him in trying over and over to dissuade Bertha from this unsuitable match. Her father had a much better match in mind for her, but Bertha was head over heels in love with Welch and wasn't about to end their relationship, so the headstrong couple eloped.

James and Bertha made their relationship official when they married in April 1902 and made their way to Breckenridge in the early part of summer 1902. We have no record of the marriage certificate, but it was likely to have been just a preacher they met on the way who performed the ceremony. Following the promise of gold, they came to Breckenridge to make their fortune from the gold and silver mines, just like everyone else who arrived in Summit County during that period. It is believed that they followed James's father, who had already tried his luck in gold mining in Breckenridge. James succeeded in getting a job at the new Gold Pan pit in town, which promised riches to be made.

The marriage didn't get off to a good start, as was to be expected. They struggled for money and, of course, with the hardships of living in a mountain town at ten thousand feet. James started to neglect Bertha, and as life got harder, he began to lay violent hands on her. The marriage was spiraling downward fast, and she tired of being treated badly by her tyrannical husband. The inevitable separation happened, and James left to find new work in Colorado Springs, possibly to follow the gold trail at a lower altitude. Bertha carried on a lonely life, but her love for her husband overcame the fear she had felt. One day, she jumped on a train and went down to find him to try and resolve their problems. The reconciliation was very short lived—only a matter of months—and he added insult to injury: James turned around and did the exact same thing he had before by deserting her in Colorado Springs too.

By now, Bertha had discovered that she was pregnant and had no choice but to leave Colorado Springs. Returning to her family was out of the question. She could not face that humiliation. So she chose to return to Breckenridge where she had already made many friends. She obtained work as a domestic for the Ed Keller family, who ran the Court Exchange Saloon on the southeast corner of Lincoln and Main Streets. One of the few people who knew of her situation found out her home address and sent word to her father in California. In the only letter Bertha wrote to him, she begged him not to tell the rest of their family of her dilemma. She confided that she had another secret for him to keep: she told him that she had learned her

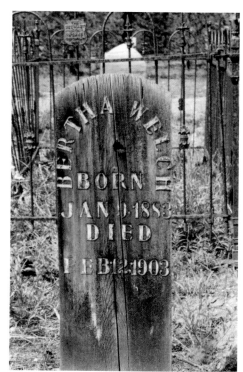

Right: Bertha Welch's headstone at Valley Brook Cemetery. *Courtesy of Lauren Lewsadder.*

Below: No. 115 North Main Street. *Author's collection.*

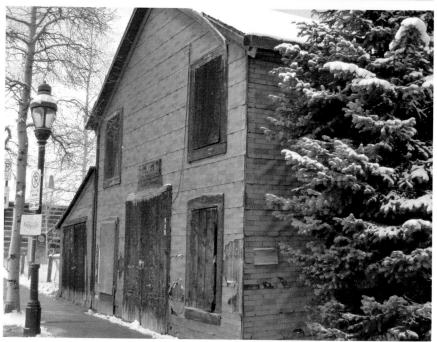

husband was insane. She believed that his family had purposely hidden that knowledge from her until they were married. In this letter, she wrote, "He loves me and is good and kind, only while temporarily insane and then the suffering is almost indescribable." It is speculated that James suffered from a then unknown form of bipolar disorder.

On February 3, 1903, in a rented room in a lodging house on Main Street, Bertha gave birth to her baby. Her son weighed thirteen pounds, and she called him Edward Cravath Welch. The birth was a difficult one, and through her extended labor, she suffered great pain, even though she was looked after by a doctor. She became very depressed about her situation and the life she had chosen, and her courage finally deserted her. She deteriorated rapidly and died just eight days later in that lonely room. On Monday, February 16, her funeral took place at Valley Brook cemetery. It was very well attended, even though she had lived here such a short time. She had made many friends during her brief stay, and the obituary written for her that appeared in the *Summit County Journal* showed how well she was liked: "Truly 'the heroes do not all die on the battlefield, nor are the martyrs all burnt at the stake,' for Mrs. Welch proved herself a heroine and took up her life and burden all alone among strangers, and with her innate strength of character and goodness of heart won many friends among us." Mrs. Florence Watson, a well-respected local poet, wrote this epitaph for her.

Even to the end, she had not wanted the rest of her family to be informed of her state of affairs. However, after her funeral, a local lady by the name of Mrs. P.H. Ryan, whose husband ran the Corner Saloon, sent word to Bertha's father to inform him of the birth and her subsequent death. A note was returned to say that the family would pay for the burial expenses and that they would come and collect baby Edward that summer. It appears that Bertha's parents never came to Breckenridge. In an article from the *Summit County Journal* of April 24, 1903, we learn that Mrs. Ryan left Breckenridge by train for Santa Ana, California, to return the child to his grandparents. They adopted and renamed him, and so a new life started for Newell Welch Cravath. He was lovingly called "Jeff" for the rest of his life. He went on to be a professional football player and had a wife and two daughters.

The building where Bertha rented a room still sits at 115 North Main Street. At that time, it was a boarding house known as Our House, built next to the popular Occidental Hotel. It was here that she gave birth to her baby boy, dying in extreme pain just over a week later. This building is no longer

occupied, but noises were rumored to be heard following her death. The sound was that of a baby crying, but it was mixed with the sound of a dying woman in her cry of sorrow just before she departed this earth.

According to the late Hans Holzer, the renowned professor of parapsychology and author of many books on the paranormal, ghosts are beings that cannot pass over to the next state of existence when they experience a very painful death, and they stay on until their unfinished business is settled to their satisfaction. I believe that was the case with Bertha. Eventually she was able to pass on after knowing that her son was settled and being brought up by her family. To her, it meant that they had forgiven her for the disgrace that she had brought to the family and she could now go in peace.

In 2011, an interesting newspaper article appeared in the *Summit Daily News* reporting a story of grave robbing. The headstone of Bertha Welch was missing, and people were outraged at this indecent act. A reward was put up for the safe return of the headstone, but no one came forward to receive that reward. Shortly thereafter, the mystery was solved. Bertha's great-niece had "borrowed" it to have it restored.

MAY NICHOLSON: QUEEN OF THE MADAMS

In 1882, soon after the railroad arrived, Breckenridge was home to three churches, two dance halls, ten hotels, a schoolhouse and three newspapers. However, it also housed eighteen saloons and two red-light districts. One of the most well-known establishments in that district was a parlor house called the Blue Goose, and its madam was the outgoing May Nicholson. An impressive redhead, she also had a good head for business. She ran her very lucrative brothel for many years until the gold started to play out, and she moved down to the lower Blue River where she opened up a dairy ranch instead. We can only guess as to how hard that work must have been compared to running a whorehouse. Nevertheless, she ran a successful dairy business for many more years and proved her worth. In her aging years, she decided to move back to Breckenridge, where she bought a house on Ridge Street and put her feet up at last. After her death, her house was eventually sold and later moved by its new owner to its current Main Street location, where it still sits today, currently operating as Olive Fusion.

Back in the late 1800s, Breckenridge had its fair share of parlor houses, brothels and cribs. There was definitely a pecking order for these "ladies of the night" or "soiled doves." If you were at the top of the ladder, you might have worked for May Nicholson or in one of the dance halls or hurdy-gurdy houses (named after a stringed instrument that was popular at that time) where the girls just had to dance with the miners if they didn't wish to take it any further. These girls often earned the princely sum of twenty-five dollars per night. The dance was free, but there was a strict understanding that the miner needed to buy a drink for himself and the lady at fifty cents for each drink. Most girls were smart and figured out that they could just drink cold tea from a glass and pocket the fifty cents for later. We can only assume that the bartender was part of the scam. If you were on the bottom rung of that ladder, however, you might only earn up to two dollars per night working out of a crib. A crib was a tiny cabin, often just one room, where there might be a line of miners outside waiting their turn. These girls were usually the youngest or least attractive soiled doves and were referred to as trollops. It was a very harsh life, even if they survived the violence, drugs, alcoholism and diseases of the job.

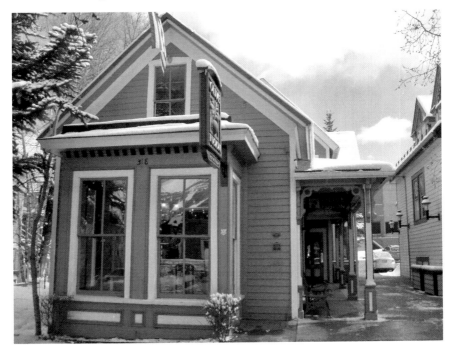

May Nicholson's house on Main Street. *Author's collection.*

There were two local ladies of the night by the name of Lillie and Mabel. They started out at the top of the ladder but fell on hard times and, before they knew it, had become crib girls. As if this life wasn't hard enough, Lillie also had a boyfriend who wasn't very kind to her. You might have expected him to look out for her and protect her from the rough miners, but he was a violent man, and one night he beat her so badly that she became unconscious. When she came round, she decided she had had enough and planned to end her life. She persuaded Mabel to join her, and the two made a suicide pact. They obtained some poison and made a lethal potion, administering it to each other. Then they lay down on the bed in their crib, waiting to die. A few hours later, friends of theirs called by. Mabel was in a heavily drugged state, but they were able to rouse her. It was too late for Lillie, however. She had passed on, we can only hope to a more peaceful place.

May Nicholson looked after her girls very well, but they weren't immune from the hardships of the job. One suicide was reported to have taken place next to the Blue Goose by one of the prostitutes jumping into the Blue River to end her unhappy existence. Others were known to drink themselves into their graves. Then the poor girls would have been buried in shallow graves on the outskirts of town, never being allowed to join other departed citizens in Valley Brook Cemetery. This was solely for the respectable people in town. We can only wonder if their spirits were ever allowed to rest in peace.

None of the crib houses survived, and the Blue Goose lasted until the 1960s, when the sign was still to be seen hanging in the front of the house. New brick buildings were constructed on that site and now house a bank and the town hall.

The Blue Goose is still talked about today but in an entirely different context: it is the name used by the local rugby team.

The Woman in Black

About a mile south of Breckenridge is a subdivision called Blue River, namesake of the river that runs through it and continues into Breckenridge. Blue River covers many acres and is home to thousands of residents. It is a picturesque and serene area, compared to the hubbub of Breckenridge, and not the kind of area you would expect to meet a ghost, let alone the grim reaper.

Kevin James* is a local guy who has lived in Summit County for about forty years. In the late 1970s, he was living in Blue River with his girlfriend. An old college buddy of his, Tommy, who was then living in Denver, called him one day to say he was coming up to Breckenridge and would like to visit. Kevin was really pleased to hear from his old friend and immediately invited him to have dinner with him and his girlfriend. Tommy told him he was going to book a room at a nearby condo block for the night as he was bringing a female friend, Julie,* with him.

Dinner was set for 6:00 p.m. that Saturday night, but when it turned 7:30 p.m. and there was no sign of Tommy and Julie, Kevin started to get very worried. Not long after that, he heard a knock at the front door and opened it to find Tommy and Julie standing there with looks of horror on their faces. It was obvious that they were both in a state of shock and related their disturbing story to Kevin.

They had arrived in Blue River and had been following the directions that they were given but somehow took a couple of wrong turns. They had gotten lost in the back streets of Blue River, which is not uncommon as the area contains a large number of winding roads that climb up and down the hillsides. Finding a particular address can be difficult, especially in the dark of night and in the depths of winter. They turned into what they thought was Kevin's street but were startled to see someone standing in the middle of the road. They could just make out the image of a woman all dressed in black in what appeared to be period costume. They stopped to ask directions, but the figure didn't speak or move. She just pointed in the opposite direction. They nervously thanked her and drove that way, glad to be able to get away from the mysterious lady. Instead of finding their destination, they drove around in a circle and came right back to the same spot, meeting the woman in black again. They plucked up the courage to talk to her once more, and this time when they spoke to her, she replied in a language they couldn't understand. They sped away from the scene, eventually finding their way to Kevin's.

After dinner was over, Tommy's friend was still very anxious and had not calmed down. She seemed to be more than just a little jumpy. It transpired that she was actually a married woman, with a young child at home in Denver and had left her home to spend a clandestine weekend away with Tommy. The incident with the woman in black had really frightened her, and she believed it was a bad omen. Instead of continuing with their

* Names have been changed to protect the contributors.

plan, she begged him to take her home. By now it was very late and a cold winter's night. Tommy tried hard to convince her to stay but she was adamant—something had to be wrong at home.

In the early hours of the morning, they set off in the car and headed back toward Denver. A couple of miles beyond Breckenridge, there is now a four-lane highway, but back in the 1970s, it was still just two lanes with a nasty bend. Just as they were approaching the bend, a drunk driver on the other side of the highway crossed over the line to their side and plowed straight into them, killing them both instantly. There were no witnesses to the accident but the tragedy of what had happened was felt by everyone who knew them.

Did they get a visit from the grim reaper, or might there be another explanation for the woman in black who led them to their deaths?

235 SOUTH RIDGE STREET: THE MYSTERY VISITOR

The Title Company of the Rockies is situated at 235 South Ridge Street and is a busy office making sure that the title to a real estate deal is legitimate before issuing the correct documents. There are many people in and out of this office, but three of the ladies who work there—Jennifer, Kim and LeAnna—have a regular visitor of their own. For many years, they have seen the apparition of a woman in the building.

One day, Jennifer asked the other two, "What is the name of our ghost?" Without hesitation, Kim replied, "Sarah." That was the name that jumped into her mind. From that day on, the ghost was called by that name. They see her floating around the office, dressed in a high-necked white blouse with puffy sleeves and a long flowing skirt. She has a habit of opening up the front door at precisely 11:00 a.m. every day and not shutting it behind her. The ladies know that the door is firmly closed beforehand, as it has to be slammed hard to make sure it closes properly. Sarah follows them around the office as they make coffee and prepare for the day's business. Kim reports that she sees Sarah's reflection in the glass partition between the lobby and the offices. In the last few years, the ladies have experienced problems with their computers. The most common fault appears to be documents that have programs altered without any of the ladies putting their fingers on the keyboard.

Who could Sarah be? We know that some ghosts were creatures of habit when they were alive and continue on through death. We know of only one dwelling that existed on this site around 1900, and this unknown lady might have lived there. She may have taken a walk to carry out errands, always returning at 11:00 a.m., or she may just have been a visitor to this house at the same time each day. Research continues for this mystery lady.

CHAPTER 2
SALOONS

THE PROSPECTOR: THE CLEAN AND TIDY GHOST

In the early 1880s, boarding houses started to appear in the mining districts. The miners who had lived by themselves in primitive cabins or, worse yet, tents were getting lonely and missing their home comforts, so many tried out the new boarding houses and then never left. They loved the home cooking, a soft bed (even if they had to share it with strangers), a lit fire and, most of all, company. There were some who were starting to go a little stir-crazy from living their solitary lives up in the mountains.

One original boarding house on Main Street was known as the Whitehead building, first run as a restaurant by Mrs. Whitehead, who was reportedly an excellent cook and very popular with the miners. Unfortunately, she died of pneumonia in the early 1900s, but the business carried on as a home for miners. However, the boarding houses weren't frequented solely by miners. There was another kind of person who lived in the boarding houses, and that was the poor widow. Having no means to return home to their origins, these destitute women would move in with the hope of finding a new husband who would then take care of them. What better place than a home full of men who had already found gold?

One of these widows was called Sylvia. She moved into the Whitehead boarding house with the intention of finding herself a new husband who would take care of her. The author prefers to call these women survivors

rather than the term that was often applied to them in this case: gold diggers. Unfortunately, Sylvia's plan didn't run smoothly. In fact, she soon caught one of the epidemics that roamed around this area. It could have been diphtheria, typhoid, influenza or even smallpox that cut her life short. Sylvia passed away shortly after contracting the disease, but she didn't leave us. It is believed that she is still with us and occupies the building along with the new owners.

For thirty-five years, from about 1970, this was the Prospector breakfast and lunch restaurant, owned by local resident Gary Reno. The restaurant was run on the first floor, and the second floor became a rooming house for long-term tenants. In a newspaper article published ten years after he took over the business, Gary reported that he became accustomed to having a female ghost around. He said that she was a dark-haired woman, about thirty-five years old, and always wore the same dress made of white lace. According to him, she usually hung out in the same room upstairs on the second floor, and he could hear her breathing softly behind him.

Many newcomers into Breckenridge found themselves living above the restaurant in the 1970s, '80s and '90s and got to know Sylvia. It is said by these former occupants that she was a very friendly and also a very tidy ghost. The female tenants reported that she loved to clean up. They testified that she tidied up their rooms when they weren't present, she folded laundry and laid it out on top of their bed and, if there were dirty dishes in the sink, she would turn on the faucets full strength to make sure they got done. At times these girls would return home and see an indentation in their beds where someone had been lying, or at night they would feel the weight of a person sitting on the bed with them though they could not see anyone.

Downstairs, she often played tricks on the restaurant owner by rearranging the kitchen items. The waitstaff often came into the restaurant in the morning and found the whole contents of the drinking straw box laid out in a neat line on the dining room floor. One male occupant who lived upstairs in 1976 looked into his bedroom mirror one day to see Sylvia's reflection standing behind him, all dressed up in her Victorian finery.

Local Kevin O'Handley, who lived there in 1973, reported seeing her as a transparent figure floating around the front bedroom of the building. At one time, his sister was visiting him, and she was perturbed to find out that her brother was living with a ghost. One day, they were leaving the building through the back door. While they were climbing down the steps, a large icicle fell from the roof and hit her on the back of the neck, causing

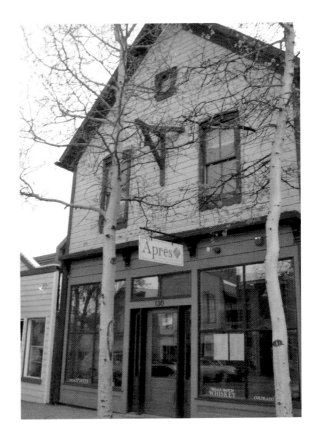

Right: The Prospector on Main Street, currently Après. *Author's collection.*

Below: An orb in the right window of Après. *Author's collection.*

a painful injury and a visit to the hospital. Was it coincidence, or did Sylvia want her out of the way?

The building has been renovated in recent years, the first floor gutted and foundations laid, but according to its occupants, Sylvia has never left. It is now called Après and is a craft beer tasting room. Ghostly Tales tours recently visited with these new owners, who were very intrigued to learn about Sylvia and are very happy to have the tour go into the building to try to communicate with her. A bartender sat at the bar that afternoon, and she related stories about her encounters with this friendly ghost. She said that she experienced glasses flying off the shelves and smashing on the floor next to her. As part of her clean-up, she mopped the floor at the end of the night and, on one occasion, experienced a force taking over control of the mop, forcing it back into the bucket to grab more water and then soaking the floor before she was allowed to continue her cleaning. One night at the close of business, she cleared the bar of dirty glasses and then moved on to clear the tables, turning her back on the bar. When she turned back to take these glasses to the sink, she was frustrated to see that the bar was again full of dirty glasses.

One final story of the building needs to be told. The manager of the Prospector related that he had been taking a nap upstairs one afternoon after an early morning start, but he was woken suddenly by a woman standing over him. Once his eyes had adjusted properly, he realized that the woman appeared to be covered in flames from head to foot. He jumped up from the bed, ran out of the building and quit his job straight after that. She was a visitor—one of the poor souls who perished in one of the many Main Street fires, no doubt.

If you visit the bar today, go to the restrooms at the rear of the first floor and stop a moment on the stairs, one of the places Sylvia likes to hang out. If you are male, you stand a good chance of running into the spirit of the widow who has never stopped looking for a new husband—her unfinished business.

THE DEVIL'S TRIANGLE

In the mining days, you didn't have to travel far in town to find a place to drink, and the same can be said of the skiing era. The Devil's Triangle, as it was known back in the 1970s and '80s, was located on Ridge Street

and consisted of three bars—Shamus O'Toole's biker bar, Angel's Rest and Fatty's. Two of the bars were on one side of the street, next door to one another, and the third was on the opposite side, creating a triangle of drinking establishments. Just like its namesake, people were sometimes known to "disappear" in the Devil's Triangle after drinking in all three bars. One of those buildings has had its share of spirit activity.

Angel's Rest used to be the town marshal's home in the 1960s. It later became Bubba's, a barbecue restaurant, and it seems that this was the time when it was most active with spirits. It was a popular place to hang out in the 1990s, especially with the bikers who drank at Shamus's. Charlie, the bartender, took pride in his job and was a conscientious worker. He liked the place to look clean and tidy, so it was very upsetting for him to be reprimanded when the owner came in and found the place dirty. He knew he had cleaned it thoroughly the night before, but the owner was finding dirty glasses everywhere, food and napkins on the floor and chairs turned over, and this seemed to be happening once a week. What the owner didn't know was that Charlie had nothing to do with this mess.

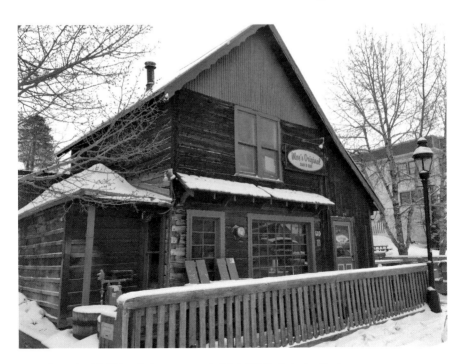

One of the Devil's Triangle bars, currently Mo's BBQ. *Author's collection.*

How could Charlie tell his boss that there was someone else with him in the bar and that it was his fault, not Charlie's—that, in fact, Charlie was being visited by a ghost?

Debbie was a regular customer at Bubba's, and she also worked across the street. One afternoon, she was over chatting with Charlie and Fiona, another bartender, when they told her all about the tall gentleman visitor. He was described as around six feet tall and wearing clothes from the 1800s, including a top hat. Debbie decided that she wanted to see the ghost for herself and voiced her request for him to show himself. At that exact moment, all the lights in the bar came on and napkins flew onto the floor.

The most notable resident of this building was Lewis Hilliard, an assayer who ran his business here in the late 1800s, when the largest piece of gold ever found in Colorado was brought into his office to be valued. That piece of gold was forever known as "Tom's Baby." Could he be the gentleman in the top hat?

The Gold Pan

The Gold Pan is the oldest bar in Breckenridge and one of the oldest bars west of the Mississippi River. Built in 1879, it started life as the Herman Strauss Saloon, one of many German-owned bars. It boasts an original Brunswick mahogany bar to sit at, a friendly looking Native American Indian statue to welcome you as you enter through the double swinging doors and an authentic 1800s potbellied stove to warm up next to. In 1905, another building on an adjoining lot was added to the business, and it became Bradley's, offering a bar on the left side and a bowling alley and billiards room on the right.

Only eleven years later, Prohibition took effect in Colorado, and the saloon had to be turned into a soda bar. Of course, there was a back room kept for the moonshine. To access this room, you had to enter from the boarding house that was located on the opposite side of Main Street. Once you had entered this building, you had to find your way to a trapdoor at the rear. From there, you descended a ladder that led you through a tunnel that lay beneath Main Street, and you finally arrived in the speakeasy. Miners were experienced at building tunnels, and this one lasted all the way through to 1970, when Main Street was finally paved over and the town had to fill it in. Before this was done, you could detect a truck passing the saloon because

the whole building would shake and you would have to hold on to your beer to stop it slopping over the sides of the glass.

Customers were still known to arrive on horseback into the 1960s, and though most tied their steeds outside, some even brought their horses inside to share their beers with them. This might account for the health department shutting the bar down in 1969 and claiming that the floor was just too dirty for people to drink in the building. The owner didn't spend long on dealing with this problem. He just bought a new piece of linoleum and stuck it on top of the old flooring, and the business quickly opened up again.

It comes as no surprise to most residents and visitors here that the last gunfight in Breckenridge occurred at the Gold Pan. The year was 1965, and the ski area had been open for four years at this point. The Gold Pan was the favorite hangout for the employees of the mountain, and this was the case on a Friday afternoon in December of that year. A young guy by the name of Eddie Chavez from a local detention center was on a work release program. He was allowed to work for the ski area on the condition that he lived with the town marshal, whose home was just over a block away. That afternoon,

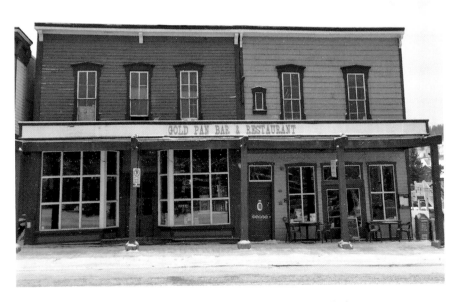

The Gold Pan on Main Street, Breckenridge's oldest bar. *Author's collection.*

there were four guys from Oklahoma in the bar playing on a pinball machine when Eddie asked if he could join them. Not only did they not allow him to play, but they annoyed him by calling him names. He was so enraged that he left the building and returned to the marshal's home, where he took the marshal's fully loaded automatic pistol back to the bar to threaten the guys. They still did not stop taunting him, and so he went out into the street and opened fire on the Gold Pan. The first person he hit was one of the guys from Oklahoma, who was shot through the knee; the second person hit was an unfortunate woman who had gone in the bar to make a phone call from the only public telephone in town and was shot in her femoral artery, nearly bleeding to death; and the last person to be hit was a ski lift attendant who was sitting at the bar. Fortunately for him, he was a smoker, and the bullet that was aiming for his heart was actually deflected away by the cigarette lighter that he had in his breast pocket. Of course, he continued to sit at the bar for many years to come and related that story multiple times over. Eddie gave himself up and was forced to leave town shortly after.

Now the activity that is felt in the Gold Pan could be any one of a number of local miners or men who liked to partake of the libations offered here, but the interesting thing is that it is a woman who is felt in the upper rooms of the building. There are a couple of apartments situated on the second floor of the bar, and the male occupants report a female hand gently stroking their faces when they are in bed at night. This building was not an official brothel, so the lady upstairs could just like taking care of sick miners. At the rear of the bar, where the restrooms are located, cold spots have been felt on a regular basis—coincidentally in the place where the speakeasy was located in the 1920s.

If you visit, check out the old safe in the north building. This is the kind of fireproof safe that was used by the miners to safely store their gold, often to be found in a saloon in the mining days. Don't expect to find any gold in it now though—it is used to store the ketchup.

CHAPTER 3
RESTAURANTS AND HOTELS

THE DREDGE: DEATH ON THE GOLD DREDGE BOAT

Breckenridge's history started in August 1859, when a miner called Rueben Spalding arrived into an area that ran alongside the river known only as the Blue River diggings. He arrived with several other miners, and they put their pans into the Blue River, drawing out $0.13 worth of gold with that first pan (the equivalent of $3.60 today). That was the start of gold mining in this area, and those first miners made a killing, as we say today. However, it is a known fact in these parts that 98 percent of what a miner found, he spent on three things—women, whiskey and gambling—which didn't leave a whole lot of extra change for anything else.

Now, not everyone became rich in this mining town, and some of those who did later lost everything. One local, Colonel Westerman, had been a rich mine broker in town until his business started to fail. He became greatly depressed and realized one day that he didn't have a penny left. He sent his errand boy off to fetch the cabinetmaker and the doctor. The boy wondered why he was being sent because Colonel Westerman looked pretty well to him, but when he returned, he realized why. Colonel Westerman had taken a revolver to his head and sent a bullet through his brain. His body was found slumped over his desk. The doctor immediately wrote out the death certificate, and the cabinetmaker measured up for the casket. He had very neatly made his final arrangements.

When the gold from the river was completely panned out, the miners went farther up into the hills and adopted a new method of finding the gold—hydraulic mining. This method had been used extensively in California and involved the men taking high-power steel hosepipes and turning them onto the hillsides, creating streams of water that washed down the gold and was then collected in sluice boxes, where the gold was sifted out. When that gold got harder to find, the miners turned to hard rock mining, using dynamite to get at the gold. That gold never ran out, but around the turn of the century, gold dredge boats were introduced to Summit County, and they took over the mining industry. They brought out of the rivers over $32 million worth of gold ($896 million in today's value). These machines were very popular with the mine owners but not so popular with the miners who had to work on them.

A dredge boat looked a little like a houseboat, with a conveyor belt at the front attached to huge steel buckets. It was known as the bucket ladder and was lowered down into the river to bedrock to pick up the gravel, silt and gold that lay on the riverbed and bring it back into the main housing of the boat. From there, the miners sifted out the gold, and what was left was deposited from the rear end of the boat into the river behind, creating piles of stones called tailings.

Working on the dredges was a dangerous occupation, and miners faced many hazards. The most common accident was drowning. Learning to swim was not common back then, and so it was a rarity if any of the miners working on the dredges could actually swim. However, they didn't stand a chance even if they could swim because they were weighted down by the heavy cotton overalls they wore and the high boots that came over their knees and filled with water. Apart from slipping off the decks, they might also have landed in the deep pond in which the dredge sat because the gangplanks they used would ice up in cold weather. That pond was between forty and seventy feet deep and always icy cold. Another common accident occurred when electricity was first introduced to enable the dredges to keep working through the night. Spotlights were installed, which provided all the light they needed. Unfortunately, the miners made no connection between water and electricity, and so electrocution was next on the list of accidental deaths. Lastly, the riverbanks often caved in and claimed more lives.

In 1930, the mayor of town, Trevor Thomas, was also the dredge superintendent. He was adjusting a steering line on the dredge (that is how the boats were attached to the sides of the river) when it snapped and broke and dragged him into the water. The riverbank caved in on top of him, and

he drowned. This happened in the fall of that year, and his body was not seen again until the spring, when the river had started to thaw. Of course, his body was in excellent condition, having been preserved in the icy water all winter. You could have been mistaken for thinking he was just asleep!

A few years before that event, a miner called William Goodwin was working on the Tonopah Dredge #1 when he fell off the slippery gangplank from which he was working. He fell into the water without anyone noticing that he had gone. We can assume that he screamed out for help, but no one would have heard him, as the boats were a cacophony of noise. Just imagine the scene—the river itself, about three times the current width, with a torrential flow; the scraping of the buckets on bedrock as they brought up the rock; and miners having to communicate with one another by means of a series of bells and whistles because they couldn't hear themselves speak.

Hours later, when the rest of the crew realized Goodwin was missing, they turned off the conveyor belt and raised the bucket ladder. The dredge master looked in horror as the bucket ladder was raised. In between the section of conveyor belt going up and the one coming down was the body of William Goodwin. It was barely recognizable. The *Summit County Journal* reported, "In recovering the body it was found that the upper part of the trunk was held to the lower part by only a shred of flesh. The body had completely been cut in twain [two]. His arms and legs had been twisted and broken and his head was an unrecognizable mass (mush). His clothing was in shreds." The date of this tragic accident was September 11, 1914.

One of the stores in town, Two Wild Sisters, used to be located close to the river in the Main St. Mall with an interior unit. Its longtime owner Tara Thompson tells how she liked to work late at night restocking the store after every other business around her had closed up for the night and the doors at each end of the mall were firmly locked. The only drawback to this was the black flashes of light that she witnessed moving past her window every night. Were these orbs the spirits of the dead miners still hanging around?

Today, if you visit the Dredge Restaurant that opened in 1989, you are looking at a replica of a dredge that sat on this section of the river in the early 1900s. It does, in fact, have the reputation of being the highest floating restaurant in the United States. You can have a drink at the bar and chat with the bartenders there. They may recount one of the many stories I have heard them tell. One story describes a male figure from the mining days being seen behind the bar after closing. Only his upper body can be seen moving along the bar, and then it disappears. There definitely wouldn't have been a bar on the dredges, so we can assume he was a miner who liked

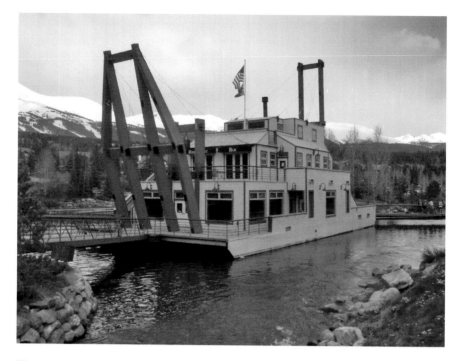

The Dredge Restaurant, floating on the Blue River. *Author's collection.*

his whiskey and enjoys hanging out there now. Another story tells of the creepy feeling that the staff members get when they visit the locker rooms that are located in the bowels of the boat, one level below the restaurant. There is a rumor that a drunk sneaked in and hid down there when the Dredge Restaurant first opened, more than likely to keep warm. As no one was aware of him being there, they closed up for the night as usual. The temperature would have been cozy warm for a short while but would have plummeted quite rapidly. He died of hypothermia.

Whatever the cause for the creepy feeling, the bartenders and waitstaff change quickly and get out of the locker rooms as fast as they can.

THE HISTORIC BROWN HOTEL

The site of the Brown Hotel was originally occupied by a miner's cabin but by 1880 was a respectable home belonging to Captain Ryan and his

family. Captain Ryan was part owner, along with Barney Ford, of the Oro Mine, which later became the Wellington Mine, the longest running mine in Summit County. His wife actually taught school at the house. Around 1900, the home was transformed into the hotel that exists today when Tom and Maud Brown took over. They installed a bathtub in one of the rooms and hoped to draw respectable guests with this feature. However, what they hadn't taken into consideration was the fact that they were well away from Main Street and close to an area that was known locally as a red-light district. Needless to say, the hotel was not a success for long, and they sold out to a single guy who tried to run the hotel as well as he could by opening it up to a more varied clientele—miners.

Not far away from the Brown Hotel was a street called Wellington Road, a very busy thoroughfare that took the miners from the train depot on Park Avenue (now Highway 9) to the popular Wellington Mine. Along this road was a row of crib houses that were frequented by the miners in all the French Gulch mines. In one of those cribs lived a soiled dove by the name of Miss Whitney. She was very unhappy with her lot and wanted to better herself by moving up the ladder in her profession. She came up with what she thought was a foolproof plan. She would seduce the new owner of the Brown Hotel with the hope that she could persuade him to allow her to take over the second floor of the hotel to run as her own bordello. From then on, she could be the madam.

Amazingly, all went well, and shortly after they met, the couple was engaged to be married. It seemed as if Miss Whitney's dream would come true. However, it turned out that everyone in the neighborhood knew of her plan except her intended. One day, someone decided to inform him of her real motive, and of course, he was shocked by this news. He wasted no time in returning to the hotel, where he climbed the stairs to the bedroom they shared and flung open the door. His bride-to-be was in the bed that they shared, and without a word, he pulled out his gun and shot her dead. He was furious at being made a fool of, and of course, that is exactly what had happened.

Ms. Whitney has never left the building and is not a friendly ghost. She makes her presence felt in the Brown by slamming doors, tipping up drink glasses, turning on faucets at full blast and generally making a nuisance of herself wherever she can. She stays because she still has unfinished business. In her case, she has her own score to settle because of her untimely death and the fact that her murder was never avenged. Her murderer was not convicted of any crime, and worse still, she did not have a funeral that we

know of. Prostitutes like her were not allowed to be buried at Valley Brook, Breckenridge's cemetery, because it was reserved for respectable citizens.

Time moved on, and the Brown Hotel changed hands a few times. By 1968, the hotel was bought out by an Austrian guy, Gunther, a retired member of the Tenth Mountain Division who had fought in World War II. He changed some things, including the name of the hotel. He called it the Ore Bucket and changed its use from a hotel to a restaurant, with rooms available upstairs for long-term rental. He created a fine dining restaurant called the Parlor, serving mostly German cuisine. Gunther was a great chef, and for many years, the restaurant was extremely successful. The good reputation of the restaurant spread, and people came from all over the county to eat here, but as time went on, there were reports that the owner's personality was starting to change. Locals said that he started to neglect the business and had problems from then on. Sometimes patrons were forced to wait two hours before being served or had food served to them that they didn't order. In other incidents, they said they might receive a steak that was burned black. Whatever the dilemma, it was best not to complain because if you did, Gunther might come out of the kitchen with a raised carving knife, stand in front of you and tell you, "If you don't like it, go somewhere else!" I speculate that a possession by the spirits of the building had occurred.

People stopped eating there, and the restaurant suffered. By 1984, the business was sold to a new owner.

The building returned to its original name of the Brown Hotel, and the new owner, Michael, ran the restaurant with his wife, Nanci, for a few more years. After this time, they decided that there were just too many other restaurants to compete with on Main Street, so they turned the business into a bar with game rooms attached. One of the most notable ghostly sightings at the Brown Hotel took place a year after they took over.

It had been a busy evening for the couple, with lots of customers visiting the restaurant. They were both tired, but Michael still needed to clean up the bar. Nanci told him how tired she was and said that she was going to go upstairs to lie down for a while until he was ready to leave and drive them to their home a couple miles away. She lay down on one of the beds and promptly fell asleep. A little while later, Michael came upstairs to wake her, but she was so sleepy that she told him to leave her there, and that is exactly what he did. He locked up, got in the car and drove home. Not long after that, she was awakened by the sound of hangers rattling in the closet. That was followed by the sound of the bedroom door flying open and then slamming shut. That happened several times. Nanci screamed, but she

was calling Michael's name, as she thought he was playing a joke on her. Of course, her husband never appeared. Finally, she realized that she had better get out of that bedroom, and so she came out on the landing and stood at the top of the stairs. Looking down into the shadowy stairwell, she saw a dark apparition at the bottom of the stairs, moving up toward her. She could feel the cold air emanating from it. When it got within inches of her face, she screamed again and ran through it. She felt as if it were following her as she ran as fast as she could out of the building. Then, with no shoes on, she ran through the snow-filled streets for a few blocks until she reached the police station, where she fell into the arms of a police officer and told her story. Obviously, she would never sleep in the hotel again and realized that the room she had fallen asleep in was none other than Ms. Whitney's bedroom.

In the 1980s, the popular TV show *The Ghost Busters* was invited to investigate at the hotel. The team of investigators carried out a thorough search of the Brown Hotel and was convinced that the ghost of Ms. Whitney was still around. Using their investigative tools, the team members sensed three hot spots in the hotel. The first was located in the basement, a cement

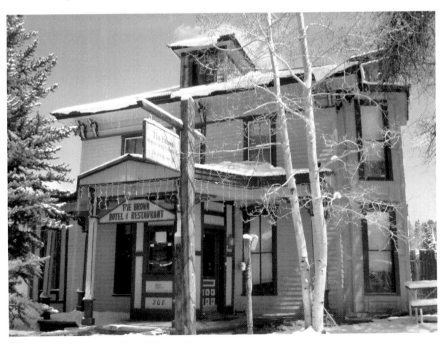

The Historic Brown Hotel on Ridge Street. *Author's collection.*

An orb on the stairs at the Brown Hotel.
Author's collection.

cellar built by Tom Brown; the second was in the kitchen, where the faucets were constantly turned on; and the third was in the ladies' restroom. You can still read the magazine article that was published after the event, framed in the hallway of the hotel.

The bar staff at the Brown Hotel has changed many times in the past years, but one bartender, Bryan, was working there when the Ghostly Tales haunted tour started visiting the hotel. Bryan told stories of being in the kitchen and washing dishes in the sink, but soon after he finished washing up, he would turn back to see the faucet on full blast when he knew he had turned it off. He reported always smelling a woman's perfume in the basement when no woman had been near it. He also showed the guide a picture he had on his cellphone. Using a reverse negative setting on his phone camera, he took a picture into the open fireplace of the front bar area. What came into view was an apparition of the top half of what appears to be a female body with a skull on its shoulders.

Female guests to the Brown Hotel report that they will not go upstairs and use the restroom alone, as Ms. Whitney likes to hang out there. She often appears in the mirror over the sinks, or girls feel shivers running up and down their backs as if they are being watched. Needless to say, the bar staff don't enjoy going down into the dark basement to bring up new bottles of liquor, either.

On Friday, June 13, 2014, Ghostly Tales tours arranged a séance and paranormal investigation in the hotel, which produced a lot of activity. One common theme ran through the evening—Ms. Whitney was trying to communicate and pass on to whoever would listen that there was an unknown third person in her story. She wanted everyone to know that another woman had been involved and played a part in her murder. From

what the participants of the séance heard that evening, it is believed that she was involved in a love triangle that turned deadly.

If visiting the Brown Hotel, you might meet the current owner, who still lives on the premises and sometimes ventures downstairs to talk to patrons. He may have the appearance of an apparition with his deathly white countenance, but don't be fooled—he's just flesh and blood.

HEARTHSTONE

The elegant Hearthstone restaurant sits on Ridge Street and was once the home of the Kaiser family. Christian Kaiser was from Germany, and when he first came to Colorado, he owned a cattle ranch in South Park, the county neighboring Summit. After several years, he decided it was time to settle down and start a family. Now, South Park wasn't known for being a highly civilized area, and as there were very few female residents, he decided to try his luck in Breckenridge. He met and married his wife, Ida, and they had four children—three boys and a girl. The boys were all strong and healthy, but their daughter was a sickly child and unfortunately died very young. The family never got over it, particularly Ida, who grieved over her daughter's death every day until she herself passed away.

In 1970, the house was bought by a new resident in town, Andrea. She had visions of a fine dining restaurant. She remodeled and decorated in the finest red velvet wallpaper, with upholstered furniture to match and created a replica of a Victorian dining room. She hung pictures of ladies of the night in the rooms and hallways and opened up Andrea's Pleasure Palace. She named the bar the Bordello and created a menu that told the stories of the soiled doves who had lived there. The restaurant was a huge success, but no one who came realized that the stories were pure invention. Ridge Street was located in a very respectable neighborhood back in the Victorian era, and the last building you would have seen on that street would have been a brothel.

The Hearthstone took over as a fine dining restaurant in 1989 and has been very popular ever since. Stu Van Anderson is a longtime local of Breckenridge, and back in the early days, he was the manager there. One evening, he was running the restaurant when a peculiar scene confronted him. He was just about to lock up the front door for the night when he noticed a woman standing in the vestibule. She was within two feet of him.

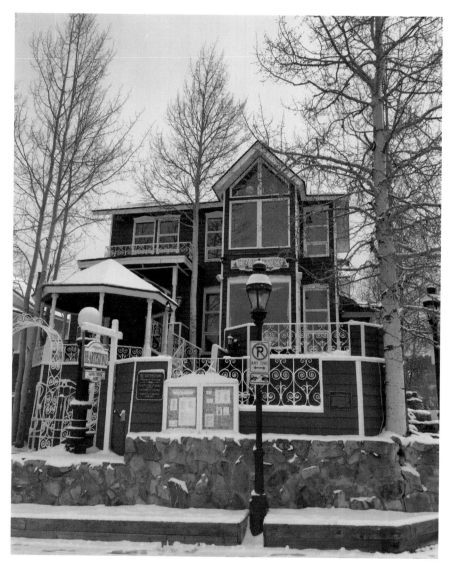

The Kaiser home on Ridge Street, currently Hearthstone. *Author's collection.*

At the same time, he smelled an overpowering scent of lilacs. Dressed in late 1800s clothing, the woman stood there with a tearful look on her face as she stared out of the glass in the front door. She never acknowledged him, and eventually he moved away. He saw her many times after that but in different locations, mostly just the edge of her long skirt draped over the stairs as she ran up to the second floor. Other staff members have seen the same sight,

including a medium who was eating in the restaurant one night and insisted on telling the manager that there was a lady still living there who was very curious as to why there were so many people in her house.

Of course, this female apparition could only be the original lady of the house, Ida Kaiser. Overwhelmed with sadness over the loss of her beloved daughter, she is trapped in the house to mourn her.

THE DANCING GHOST

In 1880, there were three local newspapers: the *Summit County Journal*, the *Breckenridge Bulletin* and the *Summit County Leader*. The historic building situated at 200 South Ridge Street housed the newspaper office of the latter newspaper. The first editor was Charles Hardy, whose daughter Kitty ran the paper alongside him. She was quite capable of running the paper by herself, an unusual attribute for a woman in those days. She was able to set type, solicit advertisements, deliver papers and even scrub the floors if necessary. She later got married and gave birth to eleven children—quite a news story at the time. Her house was situated on the opposite side of the street. If you visit that building today, you will be surprised by the size of that small structure.

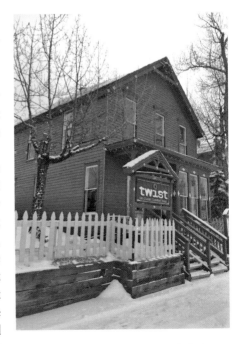

Charles Hardy had a very sociable wife who loved to host parties at 200 Ridge Street. She died in the house in 1919.

There were many changes of ownership after that, and the building served as a grocery store, a property management office and an English-style pub. Having spoken to some of the owners of those businesses, it appears as if there has been a lot of bad luck that has followed the owners—marriages have ended in divorce, and alcoholism has been another issue.

Twist restaurant on Ridge Street. *Author's collection.*

The current owner of the building runs a fine dining restaurant called Twist, and he states that he believes the building to be haunted by Mrs. Charles Hardy. Due to her love of music and parties, he reports that the volume of the music they are playing in the restaurant increases in strength when they are closing up at night. Customers have also experienced items, such as pictures, being thrown around the room. What is most interesting is that often these items are related to music, such as iPods and cellphones.

A longtime local, Sheila Jeggentenfl, believes that ill fortune has followed the owners of this building, but she believes the bad luck has stopped with the new owners, who are enjoying huge success with their new restaurant. Mrs. Hardy must approve!

CHAPTER 4

TRAGIC ENDINGS

WILLIAM KEOGH: DEATH IN THE RED-LIGHT DISTRICT

The *Summit County Journal* dated November 12, 1921, ran the following headline: "CHARRED AND DISTORTED HUMAN BODY TAKEN FROM RUINS OF MIDNIGHT FIRE IS IDENTIFIED AS THAT OF COUNTY ASSESSOR, WILLIAM T. KEOGH." The article stated that he had died in the early hours of November 8, 1921, which coincidentally had been his birthday.

William Keogh was one of Summit County's most popular social and political figures in the early 1900s. As a veteran of the Spanish-American War, William came to Breckenridge to make his fortune, like every other man who came to this district during the mining era. However, he found that a career working behind a desk offered a more reliable income. In 1900, he married Edna Buffington, sister of the famous Lulu Buffington, who was the catch of Dillon in her young days. He moved to Leadville with his job, then to the town of Robinson near Kokomo and eventually settled in Breckenridge, becoming the county assessor. William and Edna had four children, who were between six and eighteen when his wife died suddenly of a heart attack in 1919. William stayed in Breckenridge and worked hard to bring up his young family.

When the news of his death broke on that November morning, the town of Breckenridge was shocked, to say the least. One of their most upstanding citizens had died in very strange circumstances, and nobody could guess

how it had happened. As the story unfolded, the townspeople continued to be amazed at the facts.

William's charred body was found at 3:00 a.m. on November 8 in the smoking ruins of a house in the woods on the west side of Blue River. The fact that it was on the west side of the river was significant, as it meant that this house was within Breckenridge city limits but located on the industrial side of town in a well-known red-light district. Earlier that evening, O.T. Bradley, the owner of a local business called Bradley's Garage, had driven Mr. Keogh in his car from Montezuma back home to Breckenridge. Montezuma was another mining camp situated about twenty miles away. It transpired that there was another passenger in the car, a Breckenridge prostitute by the name of Dell Murphy. When they arrived in town late that evening, Mr. Bradley was asked to drop them at Dell's crib house. A fire was lit in the fireplace and an oil lamp lighted. Bradley observed all this before he was paid, and then he left the couple alone. Less than half an hour later, the house was engulfed in flames. The firefighters were called, but an unknown official who was present told them not to bother putting it out as the house was empty and there was nothing of value inside. In fact, they were told that it was a house of "ill repute," so it was not a loss to the town—rather, it was a benefit to the town if it were to disappear. So it was left to burn to the ground, but the firefighters stayed there until the early hours of the morning watching over it to prevent it spreading to the town. When the fire was out and the smoke had dissipated, they were surprised to see what seemed to be a figure lying on the metal springs of the bed. It was impossible to identify the charred remains, but when they examined it more closely they found it to be the body of Mr. Keogh. He was positively identified by the diamond ring on his left hand that he was known to wear.

An inquest was held, and evidence was given by Miss Murphy. She admitted to being with William that night. She also claimed that it was an accidental fire, but other witnesses stated that they saw footprints in the snow going to and coming from the house, as well as a figure seen running through the trees away from the house. Who could this mystery person be? Could it be an accomplice to a crime of arson? Or was it an intended robbery for the theft of the diamond ring, which could not be removed from the finger and the only solution was to burn the body to extract it?

Despite the information provided by the witnesses, the verdict was inconclusive—"not entirely accidental." No one was ever convicted of a crime, and no one followed up on the report concerning the official who gave the order to let the house burn. The funeral was held on November

A depiction of a row of crib houses in the red-light district. *Author's collection.*

10 by the Rogers and Huntress funeral home. William was buried in Valley Brook Cemetery in Breckenridge in a very well-attended funeral service. Unfortunately for William, he joined the ranks of people who died in very tragic circumstances who will never get to rest in peace.

According to the late professor of parapsychology Hans Holzer, who studied psychic phenomena for over forty years, "Tragedies create ghosts through shock conditions."

Nothing remains of the cribs or the houses of ill repute that were in abundance in that area west of the Blue River, close to what was once the railroad tracks. If you were to look for the spirit of Mr. Keogh there, you might find yourself standing in the middle of a block of condominiums or even the town hall. I'm sure William would rather be known for haunting somewhere respectable like that than the prostitute's crib in which he perished.

JOHNNY DEWERS: THE WRONGED HUSBAND

Infidelity was something that shocked the respectable Victorians, and they considered it a most scandalous event. If it occurred on their doorsteps and involved someone who was a well-respected member of the community, it was even worse. In 1898, such a scandal took hold of Breckenridge when two

well-known locals got caught up in a love triangle that rocked the citizens of Breckenridge and ended in murder.

Johnny Dewers ran the Corner Saloon on Main Street in the late 1800s and was the favorite barkeeper in town. He was married and had two children, but unfortunately, both had died at a very early age. He was also the town's fire chief.

Dr. J.F. Condon was the local physician, who was also married and a pillar of society. His practice was located on the opposite corner of the street from the Corner Saloon. As a doctor, he lived in one of the most prominent homes on Main Street.

For many months leading up to the event that took place in August 1898, there was a considerable amount of gossip in the town that Dr. Condon was having an affair with Mrs. Johnny Dewers. The most significant event was witnessed by Johnny Dewers when he saw the doctor pass a note to Mrs. Dewers in plain sight of day. This culminated in a divorce between the Dewers—itself a scandal in Victorian times. Not able to bear the shame of this, Mrs. Dewers left, and the town expected a return to normality, but that wasn't to be. The two men started a feud, constantly watching the other's movements through the windows of their respective buildings and openly arguing in public. Dr. Condon had become so nervous by then that he

The site of Johnny Dewers's shooting in downtown Breckenridge. *Author's collection.*

started to carry his revolver around with him at all times of the day, despite the fact that he was as much to blame as Johnny Dewers. We have a name for this behavior today—stalking. For all intents and purposes, it looked as if Johnny Dewers was stalking the doctor.

Their dispute came to a head on the morning of August 4 when Dr. Condon left his practice to visit a patient. Johnny Dewers had seen him come out into the street in front of the saloon and decided it was time to settle the score. It was time to bring this matter out into the open, and if it ended in a fistfight, then so be it. He approached the doctor with the intention of telling him what he thought of the doctor's actions in bringing on his divorce. Without letting him speak, Dr. Condon brought out his revolver and shot Johnny four times at point blank range. He died instantly. Without hesitation, Dr. Condon walked straight to the sheriff's office and gave himself up.

The trial that followed was lengthy, but the only piece of evidence of note was the fact that Johnny Dewers was unarmed when he approached the doctor that day. Many weeks later, when the verdict was announced, it shocked the townspeople: "not guilty." Dr. Condon had avoided conviction by claiming self-defense. Local citizens were outraged by this verdict. They felt that Mr. Dewers had not received justice. Not only had his children perished from disease a few years earlier, and not only had he lost his wife through no fault of his own, but now he had also lost his own life without atonement. Dr. Condon, meanwhile, went on to live seventeen more years before dying of diabetes.

It is rumored that there are three places you can visit the ghost of the unfortunate barkeeper who died an untimely death. The first is his grave at Valley Brook Cemetery; the second is his former home, currently the fire station's museum on Main Street; and lastly, the site of his murder in front of the Corner Saloon (the northwest corner) at the main intersection in town.

A local psychic recently witnessed spirit activity at the house where Dr. Condon lived on the corner of Washington and Main Street, particularly at the back door of the property. She saw many women walking in and out of this door, which used to be the service entrance during the doctor's time there. She also sensed that they weren't there for purely medicinal purposes. We know that he had a reputation for infidelity in the town.

The Ghostly Tales tour has carried out a paranormal investigation in the house and has had high readings with EMF meters and huge success in capturing orbs on video.

THOMAS WINTERMUTE: TRAGEDY OF A YOUNG BANKER

In 1880, Breckenridge had its second gold boom, by which time silver had been discovered and added to the treasures to be found in Summit County. The newest residents to arrive decided that with all the wealth in the county it was time to turn Breckenridge into a respectable town, rather than the old mining camp that it had been. Two-story buildings sprang up along Main Street, adding businesses of all kinds to cater to the new occupants.

A young and keen businessman named Thomas Wintermute came to Breckenridge and set up a bank to help the wealthy residents look after their new fortunes. He married into a popular local family, and just over a year later, his new bride, Clara Remine, was expecting their first child. What should have been the happiest time of their lives turned into a tragedy. Giving birth had taken its toll on Clara, and she sadly died of complications seven weeks after her daughter was born. This left Thomas alone with the new baby to look after. (The reader might remember hearing the name Remine in one of the previous stories. Helen Remine was Clara's sister and one of the girls who died of diphtheria in the story of Breckenridge's cemeteries.)

Two years later, the still grieving husband took a business trip down to Denver and was involved in an accident. While riding in a buggy downtown, he was kicked by the horse that was pulling the buggy and thrown into the street. The accident resulted in Thomas's face being extremely disfigured. We assume he also had a head injury because his friends stated that he wasn't quite right after that, and what happened next proved that to be the case.

A month after the accident, Thomas attended a local funeral at Valley Brook Cemetery. He had been drinking very heavily that day, and out of the blue he pulled out his pistol and ordered one of the locals he was with to join him in a drink from the flask he was carrying. That man declined, and the event passed without incident, but shortly after, Thomas visited the grave of his late wife and knelt down on top of it, putting the muzzle of the gun into his mouth. A family member happened to be there at the same funeral that day and pleaded with him to put the gun down. He was able to talk his cousin out of the suicide attempt, but when the marshal arrived shortly after, Thomas turned the gun on him and warned him to stay away. Thomas was persuaded to put his weapon away and returned to town. Everyone thought the incident was over and done with, but instead of going home, Thomas visited a local pharmacy and obtained a dose of morphine, drinking the contents down in one go. Still alive, he was found by friends staggering in the street and taken to a room at the Denver Hotel on Main Street. One

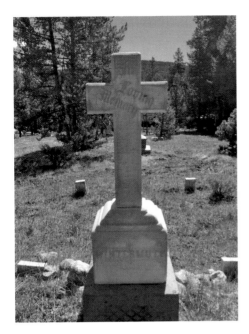

The Wintermute grave at Valley Brook Cemetery. *Author's collection.*

of his friends stayed and looked after him through the night, but the following day, he succumbed to the overdose and died at only twenty-six.

Investigation afterward found that his business was doing well and all accounts intact. We can safely assume that he had died of a broken heart.

His business was located at the north end of town, in the 100 block of North Main Street, and was burned to the ground in 1935 when a fire destroyed that section of town. The lot has been vacant ever since, but a park is being planned for that site in the near future.

As for his baby daughter, Clara Jeanne, she moved to Oakland, California, and was brought up by her aunt and uncle of the Wintermute family, living to the ripe old age of ninety-one.

Believers of the "other side" know that if a person dies having unfinished business they will stay in spirit until such time as it is settled. Thomas was undoubtedly torn between being with his departed wife and staying for his daughter. As soon as he knew that his daughter had found a home and was taken care of, I believe he passed over and joined his beloved wife, Clara.

OSHKOSH: THE LONELY BLACKSMITH

In 1974, a new couple in town, Sheila and Steve Jegentenfl, rented a house on French Street that had once belonged to a blacksmith. It came with a workshop and stable out in the backyard. Originally, it had been a three-hundred-square-foot home when it was built in 1874, but sixty years later, a new owner had remodeled and added on to make it a more comfortable space. That evidence came out when a wall was exposed with the name and date of the remodel in 1934.

After living there for a few years, the couple found that the roof was leaking a lot and asked the owner to repair it. They were told they had better buy the house and put a new roof on themselves and make their own repairs. So they did, and shortly after, Sheila started to feel a presence in the house. She had been sensitive since she was a child and wasn't surprised by this feeling. She wasn't quite sure who was with them, but she knew this person wasn't a threat.

After living there for ten years, they decided to do some remodeling of their own and put a large addition on to the rear of the property. That's when the energy and activity increased.

One night, when Sheila was by herself in the house, she was woken in the middle of the night by someone touching her on the shoulder. She woke to see a tall, dark figure standing over her dressed in overalls. The figure did not move but instead stared straight at her and then disappeared. This happened for the next three nights while Steve was away from home, but it stopped upon his return. Sheila had a nickname for the spirit now and told Steve all about "Oshkosh" when he returned. She guessed that the stranger was the blacksmith who had originally lived in the house by the way he was dressed in overalls. The activity in the house continued, with Oshkosh making regular appearances. They assumed that the construction they had done had been the cause for his appearances, as ghosts do not take kindly to changes being made in their homes.

One summer, Sheila and Steve decided to take a long road trip to California and packed up the car. After they had been driving for some hours, Sheila asked Steve if he could feel the energy in the car and told him, "I think Oshkosh has joined us for the trip!" They reached their destination in California and tried to check in at a hotel, but it seemed to be a really busy time of year, and everywhere was full. The visitor center could only come up with one option—an old hotel in town was being remodeled, and they were told that there may be one room finished, but the rest of the hotel was under construction. If they didn't mind that the hotel was haunted, then they might get a bed for the night. The ghost that they experienced that night was a young, female spirit, and she instantly made a connection with Oshkosh. Sheila reported that the energy was very high during their visit there. Needless to say, the young girl hitchhiked a ride to Breckenridge with them. From then on, the two spirits were never apart, coming and going from the house together for many years afterwards.

Steve finally got a chance to see Oshkosh for himself one night in the 1990s when he woke up and saw the apparition of a tall, dark man wearing

overalls, standing in the kitchen on the phone. The man was standing perfectly still, just holding the earpiece to his ear but not making any noise.

Sheila reports that the ghostly pair has now moved on, as she hasn't seen them for a few years. Maybe the blacksmith was ready to pass over now that he had a mate, something that he had probably longed for in life. Or maybe the warmer climate in California was more to his liking!

THE CURTIN FAMILY

The first occupants of 114 North French Street were the Fletcher family, a prominent Breckenridge family back in the late 1800s. However, it is the Curtin family members who are mostly associated with this house and who occupied it for over seventy years. Mr. Curtin had come to Colorado to work for the railroad, and his wife, Martha, had emigrated here from Ireland. They moved to Breckenridge just in time for Mrs. Curtin to give birth to the first twins born in Summit County in 1882. They named the girls Martha and Margaret, and to outward appearances, they all led a very respectable life. Their house was situated on the corner of French and Wellington Roads, and the latter was a very busy thoroughfare for the miners of Breckenridge. It led to the extremely successful Wellington Mine. Just east of the house, there was a hill that was known locally as Curtin Hill after the family. However, this area also had another reputation.

Curtin Hill came to be known as the second red-light district of the town, and it was rumored that a house of ill repute was owned by the Curtins. One of the daughters was also rumored to have had an illegitimate child. This bawdyhouse (or sporting house, as they were often referred to by the newspapers of the day) on Curtin Hill was later run by a madam called Minnie Cowell. By all accounts, this was a fairly luxurious bawdyhouse—it boasted a piano worth $1,200—and was referred to as a "sporting palace" by the *Summit County Journal* in 1909.

It was also a very lively house for other reasons—there were at least two male suicides in this building. The first involved a man by the name of Carl Halverson, whose wife was working there as a lady of the night, with his permission. At some point, he must have changed his mind about this decision and asked her to leave. She continued working there, and so he arrived one day, armed with a gun. Wielding it, he demanded that the madam bring out his wife. She had been hidden in a closet as soon as everyone realized that

The Curtin house on Ridge Street, currently the Fireside Inn. *Author's collection.*

Carl meant to shoot her. Infuriated by this, he instead went into the middle of the parlor room, put his gun to his temple and fired. The bullet went clean through his skull and exited near his left ear.

Just eight months later, another young man had a similar misfortune. A local miner by the name of Andy Goldie had recently divorced his wife and lost custody of his two children. On this day, he had been drinking heavily before he made his way to the house, armed with a gun. He started firing it inside and threatened to kill himself. A little later, he left the bawdyhouse and made his way to a nearby stable. Two shots were heard at this time, and the girls then assumed that he had left the area. However, he showed up back on their doorstep half an hour later and collapsed there. Dr. Condon was called for and found that a shot had been fired into Andy's chest, close to the heart—another distraught man taking his life because of the unhappy state of his marriage.

With two men taking their own lives in a time of extreme trauma, the building carried a heavy and depressing energy, and thus it was no surprise that it burned down on New Year's Eve 1917. Apart from the loss of the valuable piano, it may have been a blessing in disguise.

Life moved on for the Curtin family. Martha grew up to be a very sociable young lady and married her sweetheart, Martin Waltz, in January 1904. Regrettably, her mother wasn't there for the wedding—she had died of pneumonia just twenty-two days earlier. Martha was very active in the local ladies' groups, such as the Eastern Star, which was the female version of the Freemasons. Martha and Martin had two daughters of their own, Ferda and Evelyn, and settled down to family life. Martha was to live in the house on French Street for the rest of her life but not without tragedy surrounding her.

The lives of the Waltz family started to take a turn for the worse when Martin was fired from his job as a railway station agent. He had worked for the C&S Railroad for around twenty years and was the treasurer for the local Republican Party, but it seemed as if he had a lot of financial trouble, which was probably due to the fact that Martha liked to live beyond her means. Martin found it hard to keep up with his wife's spending and was accused of stealing from his employers. The scandal that followed caused his daughter Evelyn to have a nervous breakdown, and she was often to be found wandering around the local streets in the middle of the night, visiting neighbors, but when they spoke to her, she didn't know who they were. Ferda, the elder daughter of Martha and Martin, suffered with pneumonia just like her grandmother but luckily survived. Her younger sister, Evelyn, a redheaded beauty, met an untimely death when she somehow managed to be behind the family car when her father was backing it out of the barn one day and ran her over, killing her instantly.

Death overtook Martin in 1935, and his daughter Ferda followed him in 1942. She had just given birth to her first son, who was born healthy, but unfortunately Ferda didn't recover from the trauma of childbirth and died ten days later. She was thirty years old. Distraught from all the deaths that took place in the only bedroom in the house, Martha moved up to the attic above. She rarely left that bedroom and died in the house nearly twenty years later.

The house is now run as the Fireside Inn and is a popular bed-and-breakfast. It is always full of guests—skiers in the winter and hikers in the summer—and is especially well liked because of its great location close to the town and mountain. It also seems as if there is a resident ghost who likes to play tricks on their guests. This ghost has a liking for items such as cameras and jewelry. One minute they are there, and the next they are not. One guest's camera went missing, and the house was searched from top to bottom. One week later, it turned up again—in the same bag from which it had disappeared.

Last summer, a guest who was visiting for the first time complained to the host that she hadn't had any sleep. Fearing that the bed was uncomfortable or there were loud neighbors, the host was assured by the guest that it was neither. What had caused her to stay awake was the male presence that disturbed her all through the night by pacing up and down the room.

It is speculated that this male figure is the same one who has a habit of making people's possessions disappear. Maybe Mr. Waltz has some unfinished business left undone.

CHAPTER 5
THE GOOD GUY
AND THE BAD GUY

THE BARNEY FORD HOUSE

Barney Ford was a remarkable man. He is known as the first black businessman in Breckenridge and has an incredible story. The house that he built on Main Street over 130 years ago has survived, and it is an outstanding example of high-style Victorian living in a mining town.

Barney's story began in Virginia in 1822, where he was born a mixed-race slave as the son of the plantation owner and a house slave. After his mother died when he was a teenager, he was sold to new owners and moved to Georgia, where he worked at one time in gold mining. He was next moved to St. Louis and put to work on a riverboat on the Mississippi. He learned the restaurant trade there, working in the kitchens and the front of the house, too. He managed a dramatic escape from the riverboat in 1848, and the story goes that he was dressed as a woman and openly walked down the gangplank to his freedom.

With the help of the Underground Railroad, he made his way to Chicago, where he met his wife, Julia, and started a new life. The following year, gold was found in California, and the rush to the West started. Barney wanted to follow the rush and convinced his new wife to go with him. Choosing the lesser-known route via Nicaragua, they were waiting there for the next boat to take them to California when they were given the opportunity to start up a hotel. There was a lot of political trouble going on in this area at that

time, and the U.S. Navy ended up bombing Greytown, the main city, where their hotel was located. After it was destroyed, the couple travelled back to Chicago without ever having reached the gold rush. Barney's next profession was that of a barber, but he also found time to work with the Underground Railroad. He and Julia started a family, and all was peaceful again for a few years until the next gold rush hit in 1859.

Barney arrived in Breckenridge in 1860 but was not able to make his fortune. He bought into a mining claim, but it was taken away from him because of the ruling at that time that stated a man of color could not own any property. Deciding to try his luck in Denver instead, he opened up a small restaurant, which was very popular, so he continued in the restaurant business before moving on to hotels. By 1864, Barney Ford was the fourteenth richest man in the city. He also fought hard for the rights of African Americans during this time.

Colorado was working toward becoming a state, but Barney was determined to fight for the right for African Americans to vote, and so he and his group worked hard to get the vote included for them before statehood was granted. He spoke to all the influential gentlemen in Denver and had the

The Barney Ford house, the residence of Dr. Condon at the turn of the last century. *Author's collection.*

ear of high-ranking generals who ate at his restaurants. With them behind him, he then went to Washington, D.C., and spoke to all the senators who would listen. In 1876, when Colorado did become a state, the black vote was included because of Barney's efforts.

He returned to Breckenridge in 1880 to open up a new restaurant, the Chop House. Again, he was very successful and hired the best builder in town to construct a house next to the restaurant. This house was one of Breckenridge's finest homes at the time. Due to Julia's ill health, they had to return to Denver, where they lived until their deaths. Barney had been an incredibly brave and industrious man, and he lived to the age of eighty. His stained-glass window is still in the capitol building today to honor his achievements.

In the early 1900s, the house was owned by local doctor and physician Dr. Condon (see the Johnny Dewers story to learn more about the doctor). During this time, his practice was on Main Street, but he also conducted business from this house and treated patients there.

The house was later owned by the Theobald family, who made it their home from 1946 to 1966. One member of the family, Robin, was very attached to his pets while living there and couldn't bear to be parted from them, so they are all buried within the grounds. Thus we have Breckenridge's only pet cemetery.

The house is now a museum and is open to the public. There have been many reports of spirit activity in the house by employees and also visitors to the museum. One staff member consistently reports seeing indentations appear in the bedcover when she opens the museum in the mornings. Unidentified knocking noises have been heard in the kitchen, which is part of an extension built off the original home in the 1930s. Reports have also been given from a local psychic who has seen spirit activity around the rear entrance of the property. She saw many women walking in and out of the door, which used to be the service entrance during the doctor's time there.

One docent, who was completely alone at the house, reported sitting in the back room by the kitchen when she heard the modern CD player in the front room suddenly start up at full volume. She assumed someone must have entered from the front of the house and went forth to greet them, only to find that there was no one in the room, just the CD player playing classical music by itself. Later on that day, the same docent was locking up the front of the house to close for the evening. She had just finished arranging all the brochures on a small table in the hallway when she turned her back on it to lock the front door. Upon turning back around to face the table, all the

brochures were on the floor, even though there had been no gust of wind nor had she knocked the table at any time. The final straw came for her when she was in the back room getting her bag to leave for the evening, and she heard a loud disembodied voice cough right in her ear. One can only guess that a patient had come to see Dr. Condon and was not happy about being ignored.

WHATLEY RANCH

There are some parts of Summit County that were left untouched by the ravages of the gold mining era and managed to keep their tranquil setting amid the devastation caused by that industry. Some homes and ranches kept a semblance of the pure West that many had traveled to in search of their dream home. The Whatley Ranch is one such site and lies in a secluded valley on the outskirts of Breckenridge.

Barney Whatley came to the town from Alabama, where he had been a justice of the peace and probate judge, to homestead his ranch. After he had established himself in Breckenridge, the rest of his family followed. They included his mother and his father, Martin, and five siblings. He opened his law offices in Breckenridge and Leadville and was very successful, advancing to become district attorney. The Whatley family seemed to lead an exemplary life to the outsider, but there was a skeleton in the cupboard. One brother and one sister had been forced to leave the family home shortly after they arrived because of Martin Whatley's aggressive personality. He argued with them and ordered them out of the house, creating an awkward atmosphere there that was not peaceful.

Amy was another of Barney's sisters who lived at the home with her own small child. One day she quarreled with her father over the whipping of her child. The argument got out of hand, and Martin told his daughter to leave the house. At the same time he reached out toward his gun, which he kept on a shelf close by. Barney overheard the argument and rushed to the room. He was overwhelmed at the prospect of losing yet another sibling and tried to reason with his father but to no avail. Barney envisioned his father pulling his gun on them, and so he pulled out his gun and shot his father twice before Martin could reach for his own gun. Barney watched as his father staggered over to the shelf and realized that his gun was missing. Martin then went out of the house via the back door to find another gun that was stored outside. Barney quickly locked the

back door and ran to the front door to make sure that was locked too. He needn't have worried—Martin had been fatally shot and got no farther than the porch, where he died a short while later.

There was a lengthy trial, during which his widow, daughters and sons all gave evidence of a history of violent outbreaks of rage from Martin. The *Summit County Journal* of July 8, 1916, stated, "They told of attacks with weapons of various kinds, guns, knives, whips—anything within his reach; of frequent attacks on sons and daughters."

At the end of the trial, the verdict was accidental death, which was a huge relief for the family. Life carried on for the Whatley family until Barney moved away to Denver to marry and start a new life, leaving his mother to care for the ranch until her death.

In the 1970s, the county coroner was Olin Mueller, who also happened to be caretaker for the ranch for some time. At this point, Summit County did not have a mortuary, so the coroner had to transport bodies in his station wagon, which also served as an ambulance, to Idaho Springs or Leadville. If a storm had set in during the winter, bodies sometimes had to be kept in the barn of the house for several days until the weather cleared up enough for him to make the dangerous drive over Loveland Pass to get to Idaho Springs. As coroner, he took many pictures of the corpses—often naked pictures—and it is said that he had a weird sense of humor too. He loved to pass around these photos, especially at parties so that he could shock his friends. The horror on their faces really amused him.

Alfred "Al" Whatley, Barney's son, was the last occupant of the family ranch, and he lived there with his wife for many years. This was Al's third wife, as he had already been through two acrimonious divorces. Al was not a popular man. He was rumored to be a liar and had some shady deals with developers and investors for his property. Apart from his personal life being beset with bad luck, Al also had a lot of financial hardship during his time there and ultimately had to hand over the family home in June 1993 to a developer as part of a U.S. Bankruptcy Court ruling.

This company had huge plans for the ranch. According to the *Summit County Journal* of January 27, 1994, the original plan had been to build a golf course, but that was turned down. Instead, the company planned to add another 585 acres of forestry land to the original 489 acres belonging to the Whatleys and build a ninety-room log lodge with a large restaurant, townhomes, employee housing, lots for sale etc. and also cross-country ski trails and horseback riding trails. This optimistic venture never came to fruition, and the ranch was eventually sold. The ranch has certainly seen

its fair share of misfortune. A local who knew Al very well believes, like other longtime locals, that bad luck has followed this property ever since the day that Martin Whatley was shot by his son. With everything that has happened at the ranch, one would not be mistaken for assuming that there is a curse over the property. Perhaps Martin is avenging his traumatic death from the grave.

CHAPTER 6
MINING TALES

FAMOUS MINES OF BRECKENRIDGE

The Country Boy Mine is one of the oldest mines in Summit County and was established in 1887. It is located in one of the richest gold-producing regions in the country. French Gulch contained numerous mines that produced gold, silver and zinc until the 1930s. One lead-producing mine kept going until the 1970s. Although considerable fortunes were made, the mines were not all success stories.

Tragic death was a common occurrence among the miners, but disfigurement and maiming were daily events too and often resulted in the end of a miner's career, if not his life. There was no form of health and safety that we take for granted today. It wasn't until 1900 that a mining inspector was given the task of inspecting the conditions in which the poor miners were forced to work. Being a miner in those early days was a challenge—a challenge to stay alive, that is. Miners faced many hazards during their labor, including being crushed during cave-ins, dismembered by blasting accidents and maimed by machinery. Here are a few of their amazing stories.

Mr. W.H. Merkle was a blacksmith and miner at the turn of the century and owned many mining claims. He was working one of his claims close to the Country Boy one day. He used three sticks of dynamite in the drill hole he had made, but the fuse misfired. When he went to check on it, the load suddenly went off, and a huge explosion followed. The *Summit County Journal*

of January 6, 1900, reported the result: "With the exception of the thumb, his right hand was completely severed; his left eye is shot out, a drill was driven through his left cheek, while the top of his head received several deep scalp wounds."

As he was alone that day, he started the long walk back to Breckenridge, trudging through the deep snow, but he was lucky that a local who was out on her sleigh happened to notice him and took him back to the doctor, where his horrendous wounds were dealt with. Amazingly, he survived that ordeal.

Another successful mine of the day was the Jesse Mine. A miner by the name of Ed Winslow worked there and lived in a cabin close by with his wife. One day, his brother-in-law Adolph came to visit them. Ed finished work at his usual time of 5:00 p.m. and came home. He greeted his brother-in-law as he walked into the main living area and then carried on into the bedroom, the only other room in the cabin. Here he washed up and changed while his wife prepared supper for them all. Meanwhile, Adolph was admiring a gun that sat on a shelf in the front room and asked his sister if they might go outside and do some target practice. She told her brother to wait until after supper and then Ed could join them, so Adolph replaced the loaded

Left: Country Boy Mine, Breckenridge. *Author's collection.*

Right: Country Boy Mine adit (tunnel) into the mine. *Author's collection.*

gun on the shelf, which happened to sit on the dividing wall between the two rooms. At that point, the gun accidentally went off, the ball passing through the partition wall and hitting Ed in the side of his body. Incredibly, the ball passed clean through his ribcage and lodged in the opposite side of his body, having gone straight through his heart. He was killed instantly.

One of the most productive lead mines in the county was called Mountain Pride, owned by local merchant Charles Finding. Fire was a huge problem back in the 1800s, and it was especially a problem if one occurred underground. A fire started one day in the tunnel house of the Mountain Pride, which was connected to the old shaft. Three

Breckenridge Mine. *Author's collection.*

men were working down there when smoke filled the area. It was not obvious where the fire was coming from, so they had two choices: exit through either the tunnel house or the shaft. They disagreed over which way to exit safely and so split up. Two of the men chose the tunnel exit, and one chose the shaft. Only one person survived that day. The other two were burned alive, trapped in the tunnel.

Today the Country Boy Mine is the only mine still open and offers tours for visitors. You can relive the life of a miner and walk the long, dark mile into the mine. Of course, you are provided with a miner's headlamp to light your way. Guests on the tour always have their cameras handy and have captured many orbs along the way. Some spirits of the deceased miners seem destined not to leave.

THE OLD HOSPITAL

Dealing with the many epidemics that came to the town was a huge challenge. They included diphtheria, typhoid, scarlet fever, smallpox and

influenza. Another common illness was from "the puff," a common lung disease that came from the dust created when using air drills. Air drills were commonly used to create the tunnels in the hard rock mines, but their nickname became "widow makers." Once the dust had got into the miners' lungs, pneumonia usually followed. Today, we call this silicosis. Mine camp epidemics were common and then often passed to the children. The worst killers of the late 1800s were diphtheria, smallpox and typhoid fever, without any treatment available. Remedies for other diseases included such amazing cures as mustard plaster for pneumonia (a mustard seed poultice was placed inside a bandage and then placed on an arm or leg), mercury for syphilis and gonorrhea (injected by means of a syringe into the urethra) and a steam cabinet for influenza so that you could "sweat it out."

Other medications like painkillers proved to be killers in disguise—teething medicines for babies contained morphine, tranquilizers for adults contained opium or Nervine (bromide) to calm the nerves and heroin was advertised to cure your cough. Even common drinks weren't safe. For example, Coca-Cola contained cocaine, and let us not forget 7-Up, which included lithium. Today, this ingredient is used to treat manic depression.

The Chicago Benedictine Sisters provided the first hospital service in Breckenridge in 1886 close to the site where the old schoolhouse sits. It serviced the miners of the town and was administered by two Sisters with the help of the local doctor, Dr. Arbogast, whose practice was in a building that still stands on Main Street today. Frozen limbs were one of the most common problems for which the miners sought help, and they paid one dollar per month into a fund, just like health insurance today, that entitled them to surgery and visits from a doctor.

Around 1906, one of the most extravagant residences in town was on South French Street. Owned by local mine owner Mr. Keables, the house drew a lot of attention. He was part owner of the successful Masontown Mine in Frisco. The whole town of Masontown was completely destroyed by an avalanche in the 1920s, and its path can still be seen near Frisco today. This house was sold to the county commissioners for $2,500, which was a considerable amount back then when the old hospital building run by the Sisters was sold for a mere $25. It became the county hospital thirty days later and served that purpose for several decades, until it was taken over and bought out by a nurse who used to work there. Bonnie was very attached to the building and wanted to continue caring for the ill and infirm residents of the town. It became her very own retirement home.

Mining died out, and Bonnie passed away. Now a different "gold" took over. By early 1961, Breckenridge had become a ski town with an impressive ski area built up by Bill Rounds from Wichita, Kansas, who first came to the area to open up a lumber company. He became the new owner of the old hospital and converted it into a ski chalet. It was in sore need of remodeling by now, and he provided a much-needed, contemporary lodge for the skiers by adding showers and a sauna, as well as upgraded bedrooms and a modern kitchen.

By 1967, it had been sold to longtime residents Robert and Lois Theobald, who lived in the house until their deaths toward the end of the century. Since then, it has been rented out by the family and divided up into three units.

The upstairs apartment is currently occupied by a local resident named Alex. He has a spacious two-bedroom apartment with a large living area and has lived there for a few years. During the time that his girlfriend lived there with him, she reported feeling as if they were being watched the whole time. On one occasion, she saw the apparition of a lady with a white apron on, moving about the living room/kitchen area. This kindly looking female

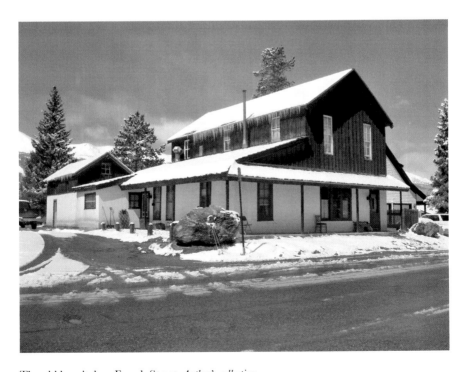

The old hospital on French Street. *Author's collection.*

seemed at home, as if she knew her way around. One day, Alex's girlfriend witnessed the apparition of a tall man in that room. She described him as having a wide moustache and wearing a dark vest. She was disturbed by these sightings and became so nervous that she never wanted to sleep alone in their bedroom.

The unoccupied basement was used as a morgue during the time of the hospital, with an oversized door to the back of the building to allow coffins in and out and a large drain in the middle of the room. There is an oversized sink on one wall and piles of old trunks and boxes on the other wall. In the farthest corner of the basement sits an old furnace and the disused sauna from the ski chalet era, complete with ski lockers. An air of melancholy is tangible as you walk through this area.

I invited a local sensitive to join me at the property one day. While we were standing in front of the building, and without knowing a single thing about the house, the sensitive described a scene involving many people who were rushing about outside—women with long skirts, white blouses and aprons and men dressed in black suits with top hats. The men were seen carrying a coffin away from the building. The women seemed to be carrying linens in and out of the front door. We were invited by Alex to the house one night shortly after this event and encouraged to bring dowsing rods and EMFs (electromagnetic frequency readers) with us. Alex was curious to know if the nurse was still there. Our equipment indicated that she was. Fortunately, we didn't meet the morticians in the basement.

CHAPTER 7
STRANGE BUT TRUE

THE OLD COURTHOUSE

The original courthouse of Breckenridge was built in 1909 of the finest red bricks brought up on the train from Denver. The residents of the town had waited many years for this permanent structure to be built and were all present for the laying of the cornerstone ceremony by the local Freemasons in July of that year. No expense was spared as gold dust was added to the cement that created the cornerstone. The building still stands as one of the most impressive in town today. One of the most fascinating parts of the construction was the fact that it included a time capsule that held memorabilia from the town's history, including newspapers, documents, coins and books. To enrich the historic interest, the officials also added a few gold nuggets to the tin box and set a date for the time capsule opening, one hundred years in the future.

One of the revelations during the ceremony that took place in 2009 was the fact that the gold nuggets were missing from the inventory. We can only imagine the shock felt by the spirits of the former residents when they oversaw the opening of the box. Too bad they couldn't speak to clear up the mystery of who might have stolen them just before the box was sealed.

The courthouse has a long history of importance in the town's significant events. A strip of land that included Breckenridge had supposedly been left off the maps and never annexed to the United States, so it was called No

Man's Land. Because of this, the town decided to call itself a "kingdom," believing it had the authority to do so. In 1936, this strip of land was annexed back to Colorado, and a huge flag-raising ceremony took place at the courthouse. Every August, well into the late twentieth century, the town held a celebration of this event, with parades and exhibitions.

In 1957, the one and only television in town was situated at the courthouse, and all the local residents who wanted to watch gathered around inside the courtroom. Viewing started at 6:00 p.m. every night and lasted until 10:00 p.m., when the generator usually ran out of gas.

Of course, it mustn't be forgotten that this building was a courthouse after all and saw the criminals of Summit County pass through on a daily basis. In the late 1960s, there were charges made against a Frisco doctor for attempting an illegal abortion. The woman hemorrhaged and nearly died. When a fetus preserved in formaldehyde was found at the doctor's house, he was found guilty of his crime. In case the verdict was overturned, the fetus was kept in the vault in the courthouse until 1973, when it was handed over to the coroner. I am not sure of its current whereabouts.

The town jail was always situated on the site of the courthouse, even before that building was erected. In 1899, the board of county commissioners voted

The old brick courthouse on Lincoln Avenue. *Author's collection.*

to build a new jail to replace the outdated and inefficient original one of 1877. They advertised for bids, and the winner was Charles Finding, a local merchant. Unfortunately, the construction of the new jail was not good enough to prevent jailbreaks, which happened on a regular basis. Ironically, the new jail was even worse than the original, and when the brick courthouse was built in 1909,

NO MAN'S LAND
DANCE
2nd Saturday in August
9 pm - 2 am
$5.00 Couple $3.00 Single
Cash Bar

A ticket to a dance for the No Man's Land celebration, circa 1970. *Author's collection.*

the town installed the original cell into its basement. It served the town well for the next sixty-four years. A second cell was finally built in 1952 when two women were arrested and there was nowhere to house them. The next change came twenty years later, when the town built the annex and the jail was moved there. At that time, it housed fifteen inmates, but there were often fifty or more incarcerated on the weekends. That was due to the judge at that time—Judge Jewel Smith-Biddle—whose nickname was the DUI hanging judge. Because of the overcrowding, one drunk was put in solitary confinement one night in the 1980s and given just a sheet and blanket to sleep with. There was no furniture in the room, but the inmate managed to make himself a noose from the torn-up sheets and hanged himself shortly afterward from the ceiling vent.

The building is still in use as the clerk and recorder's office and county commissioner's office among other official offices, and I have interviewed several employees who currently work there. They all assure me that it is a happy and congenial place to work, but is there something they are not telling me?

THE STENOGRAPHER

Esther Brooks was born and grew up in Breckenridge. She was actually born on site at the Mountain Pride Mine. During her youth, she excelled at her schoolwork and graduated with honors. All her teachers stated that she had great prospects. After training to become a stenographer, she started working for the Tonopah Placers Company, considered to be a very good

career move for a woman in the early 1900s. She was regarded as a pretty girl, and no one was surprised when she started seeing a young man who also worked for the company. In December 1919, the couple was married and looked forward to a long future together. Less than two months later, she was dead.

The bizarre accident happened when she was visiting her parents' home one day. The family was all seated in the living room. It turned out that their next-door neighbor was planning a hunting trip. He had been cleaning his revolver in his living room, and when finished, he placed it in his suitcase, which was already sitting in the room ready to go. He packed it between his clothes and then shut it tightly. Unfortunately, after picking up the case, he tripped on the carpet and dropped it. At the same time, the gun accidentally discharged inside the case. Remarkably, the bullet travelled through the suitcase, made its way through his living room wall, through the wall of Esther's parents' house a few feet away and then continued into Esther's parents' living room, where it struck her between the left eye and nose. The bullet lodged in her skull, and she died of her injury several hours later.

THE SKI AREA PHENOMENA

Breckenridge Ski Area opened in December 1961 with one mountain—Peak 8. It was all due to a man called Bill Rounds who had moved to Summit County from Wichita, Kansas, a few years earlier. He had arrived here to open a lumber company and had bought up many acres of land. As it happened, Bill's hobby was skiing, and he invited two Norwegian ski instructors from Aspen to check out the mountain with him. Trygve Berge and Sigurd Rockne were impressed with the slopes and encouraged him to open the mountain up to the public. The ski area opened with only one mountain face and two lifts but was an immediate triumph. The Norwegians formed a ski school, and people paid four dollars for a day's lift ticket. All went well for a few years—until a strange event happened on January 10, 1966.

It was a quiet Monday afternoon, due to the fact that at that time skiers only visited on the weekends, and on weekdays there might only be a handful of people skiing. There were thirteen employees working in the administration building, known as Ullrdag Lodge or Ullrhom after the Ullr Dag celebration for the Norse god of snow. This event had been introduced

by the Norwegians a few years earlier because business was so slow in January—during one particular week, they sold only two lift tickets.

Just after lunch, a loud explosion was heard everywhere in the valley. Down in town, people stopped what they were doing and looked up toward the mountain but could see nothing. The firefighters got their truck out because they felt sure a fire was going to follow shortly after. They headed up the mountain, watching closely for any signs of smoke but found no evidence of any. When they arrived at the ski area base, they were surprised to see no flames in sight. It took a short time for the dust to settle before they realized that although there was no fire, the administration building had disappeared!

The explosion that everyone had heard came from butane heaters in the crawl space of the building. A faulty gas regulator was the cause. The whole structure had risen up into the air and then collapsed into a pile of rubble. The extent of the damage was that twelve people were injured, and one person died. The ski area manager's secretary was blown completely away from the building. She ended up in the parking lot, and her hair was totally burned from her head. If this accident had taken place just one day earlier, over one hundred people would have been in and around that vicinity, and the death toll would likely have been much higher.

In 1969, the operators of the ski lodge, the mechanical contractors, Public Service Company and the architects were all found guilty of negligence and forced to pay $225,000 to survivors of the explosion.

Thankfully, this event didn't stop people from skiing, and the ski area continued to boom. However, there have been other strange happenings on a different part of the mountain. The second part of the ski area to be developed in 1973 was Peak 9, which became a very popular mountain because of its long, gentle runs that are especially pleasing to beginners. One run in particular has become a favorite with skiers—Lehman, which lies on the southernmost side of that mountain, close to the forest boundary. Close by is a cabin that is part of the Hut System. Skiers and snowshoers make their way up the mountain to the huts and can stay overnight. Francie's cabin is one of the most popular and sits just outside the boundary of the ski area near Peak 9. Snowshoers and skiers who stay there have to book far in advance to get an overnight stay. Some people who stay there experience a very restful and peaceful night after their hike up, but for others—the more sensitive and psychic among us—it is far from quiet. For them, there is no peace as Native American Indians are seen in large numbers moving through the cabin. It is believed that an original Ute camp sat on this site in the mid-1800s and became an important meeting place for their powwows.

For these sensitives, it can be a sleepless night while the activity is all around them. It is possible that this is a portal through which spirits enter.

Lehman run is divided into two parts—Upper and Lower Lehman. Locals report that there have been many accidents on this trail. Skiers have related stories of seeing Native American Indian children playing in and around the trees that adjoin the run. There have been multiple crashes into the trees that adjoin Lower Lehman. It is not pure coincidence that the skiers have been distracted by the movement of the children they witnessed and veered off into the trees.

An Unsuited Couple

Chuck and Sharon Garrison were a well-known couple in Breckenridge in the 1990s. Sharon Garrison was a bubbly brunette, five feet five inches tall, who enjoyed a lot of outdoor hobbies like fishing, horseback riding and hunting. She owned property in Idaho Springs and ran a couple of businesses in Manitou Springs. Chuck was a business owner and ran an alarm company in Breckenridge, and they lived in a secluded house on many acres very close to the Breckenridge golf course.

However, they did not have a strong marriage. It was the fourth one for each of them, and it had been very stormy from the start. Both were strong characters, and the relationship was very volatile. Of the ten years they had been married, five of those held documented incidents of domestic violence, and Sharon had even gone so far as to record audiotapes of the arguments that took place.

Sharon had been down to her property in Idaho Springs on September 27, 2000, and was returning to Breckenridge on I-70 that evening. As far as everyone who knew her was concerned, she never returned. She was very close to her three daughters, who were obviously very concerned when they didn't hear from her for the next seven days. Whenever they phoned Chuck to inquire about her, the story they were told was that she was visiting friends in Clear Creek County, on the way to Denver, or she was in Manitou Springs.

She was officially declared "missing" in the *Summit Daily News* on October 5, 2000, and posters were put up throughout the area offering a reward for information concerning Sharon's disappearance. Four days later, her car was found in Clear Creek County, just off the interstate, but there was no sign of Sharon. During this time, Chuck Garrison decided to have some landscaping work done on his property, including backfilling

dirt into holes on the property. He had told the landscaping company that the job was urgent. Although he carried out the work, the landscaper had become suspicious and decided to alert the police. The following day, after obtaining a search warrant, the police searched the grounds of the Garrisons' house. At first, the search turned up nothing on the grounds or house, but then the police decided to investigate the newly filled holes. The investigators dug down ten feet under the new dirt and uncovered a tarp. Wrapped inside the tarp was a carpet, and when they opened up the carpet, they found a body rolled up within it. The body was naked and had been strangled, as well as had obvious wounds to the head.

So what happened that fateful night? It is believed that the couple had been arguing over money, as they often did. Sharon had been threatening to leave him, as she had done so many times before. Sharon had also consumed several alcoholic drinks that evening, and the argument escalated. By now, they had moved down to the hot tub, which was located in the basement. A fight ensued, which escalated into an attack. Chuck held her by the throat and started to strangle her, and in his rage, he reached out to grab an ornamental ice pick from the ice bucket sitting on the bar that was next to the hot tub. Chuck then brought the ice pick straight down into Sharon's skull multiple times before killing her. Once he was certain his wife was finally dead, he wrapped her body up in a rug, then he found a piece of tarp and rolled the carpet in it and hid her body. He came back and scrubbed the hot tub area as best he could, but he couldn't quite reach between the boards of the wooden flooring, and that is where the forensics team found traces of her blood. Sharon was discovered on October 18, and Chuck was arrested the very next day.

After the trial in 2002, Chuck was found guilty of first-degree murder and sentenced to thirty years in prison. People called it a "crime of passion."

There is one strange fact that emerged during the trial. Eerily, during a heated domestic violence incident back in 1998, two years before the murder, Chuck threatened to kill Sharon, and according to the *Summit Daily News*, he told her, "I will probably live in a penitentiary for the rest of my life, and you will be dead." She called the police immediately and told them that he wouldn't kill her that night, but she wanted them to be aware in case they found her body sometime in the future.

THE ENDEARING ROGUE

Close to the town hall in Breckenridge used to be the office of Royal "Scoop" Daniels III, once a well-respected attorney who took on a lot of pro bono work. He had been a dedicated member of a local church and often sang in the choir and helped with jail ministry. In fact, he helped with every charitable organization he could. On April 27, 2007, all that changed.

He arrived at his office around 5:45 a.m. with his faithful golden retriever. He made coffee, ate a bowl of cereal and settled down to do some paperwork. At 7:45 a.m., however, the security cameras recorded him leaving the building. At 3:00 p.m. that afternoon, when he hadn't shown up for several appointments, his secretary checked his office. His dog, coat and keys were still in their usual place, but there was no sign of Scoop, so she called the police. It seemed as though he had vanished into thin air. Everyone suspected the worst. As Breckenridge is a small town, there were several dramatic theories being discussed: he had been kidnapped, he had had an amnesiac attack or there had been foul play and he was lying in a ditch somewhere. One strange fact emerged—a 911 call had been made from his cellphone at 7:48 a.m., but no one spoke. Within hours, police had sent in bloodhounds to search for clues.

The next day, posters were put up all over town for the missing attorney. A manhunt was organized, and every part of the town was scoured. The whole town was in shock because everyone in town knew him. It was then time to interview all his friends and clients. His friends told how he attended a local fundraiser the night before his disappearance. He even paid for his whole table, but it seemed as if he wasn't his usual jovial self that evening. Instead, he sat very quietly, hardly speaking and appearing deep in thought. When his girlfriend was interviewed, she said that on the last morning she was with him, he gave her his favorite hiking boots and told her he wouldn't be needing them for a while.

His clients and coworkers had a different story to tell. In the following few days, it came to light that Scoop was in huge financial debt in his personal life. One of his responsibilities as an attorney was to run a 1031 exchange, a real estate escrow account. This allows people to "hold" the proceeds from the sale of one house before moving to purchase another house without incurring any taxes. He had moved money from this account into his personal account. It was estimated that he had stolen up to $1 million.

Rumors were now rife that he had flown to Brazil, a country that he loved and visited frequently. Adding to the validity of the town rumor mill was the fact that he also happened to be fluent in Portuguese.

Five years later, on a normal day at the United States–Mexico border, a man's passport was checked at a pedestrian checkpoint and the agent was suspicious. He made a phone call and found that his hunch was right. Standing before him was Royal "Scoop" Daniels III. He was arrested immediately and sent to the San Diego jail; from there he was transferred to Breckenridge. Four months later, he went to trial and was sentenced to twelve years in prison for felony theft. Needless to say, the courtroom was full of angry people during his trial, locals who had lost all their savings. In explanation to the court, he told his story of what happened that day in 2007.

His first thought had been to commit suicide when he realized how much debt he was in. When he walked out of his office and made his 911 call, it was a cry for help. Then he changed his mind and instead rode his motorcycle out of town, abandoned it when it ran out of gas and took several buses until he got to Mexico. There he made his way to Acapulco and found work as a translator, settling into his new life.

We can only guess what brought him back to the United States—maybe it was the lure of his social security checks or the guilt he felt for what he had done.

I was present at the fundraiser the night before Scoop disappeared and can confirm the details of that evening. I was also a client of this attorney and luckily can report that I had no problems myself.

Scoop is still serving his sentence today and spends his time writing his memoirs. We may never know all the details of this case until the book comes out, but I am sure there will be a long line of people at his book-signing event with questions they all want answered.

HALLOWEEN TRAGEDY

In 2002, it was rumored that Breckenridge had a "bad boy" image, and even the *Denver Post* wrote an article with that suggestion. Many locals believed that the paper was justified in writing that article because the advertising slogan for the town that year had been: "The hill may dominate you, but the town will still be your bitch." It was not popular with the

townspeople and was soon dropped. During that year, Breckenridge had a total of seventy-nine liquor licenses in operation. Comparing that figure to the number of saloons in 1882—only eighteen—it makes the Wild West era seem tame. You might be forgiven for thinking that this next story took place during that era, too.

It was Halloween night in 2002, and there were parties going on everywhere. Main Street was rocking. One bar in town, a New Orleans–style bar called Mambo's, was having an exceptionally busy evening. Cody Wieland, a local guy, sat at the bar drinking by himself when three other locals walked in and joined him to order their drinks. Somehow, an altercation broke out, and insults were thrown back and forth between the four men. The bartender tried to break up the argument but with no luck. He ordered them to leave, and the men took the argument outside to the sidewalk, where it grew more intense. By now, it was around 1:00 a.m., and Wieland had decided he was tired and wanted to head home. He walked away from the young men and headed south on Main Street. However, he was followed. When the three men caught up with him, they slammed him down onto the concrete sidewalk. As he fell, he hit a wrought-iron fence close by. It is unknown whether he sustained any injury at this point, but the three men continued to kick and beat him with no mercy. One of the men took off his heavy metal helmet that he had been wearing for a Halloween costume and hit Wieland around the head with it. Two witnesses who had been near the scene jumped in to try and stop the bludgeoning, but the young men did not stop until their anger had abated. Wieland was abandoned on the sidewalk in a pool of his own blood.

The police arrived shortly after, and he was taken to hospital, where he immediately underwent surgery, but a few hours later, he was declared to be clinically brain dead. Ten days later, he was removed from life support. It didn't take long for the assailants—Robbins, Stockdale and Dietert—to be caught, and a lengthy trial ensued. They were all found guilty of killing Wieland and sent to prison for the crime. The real reason for this horrific crime was never made clear, but one statement from Levi Williams, a witness, seemed to sum it up: "such anger, it was a stupid argument that got out of control."

Strangely, one of the men turned out to be familiar to everybody in town—Brandon Robbins, who had been wearing the "heavy, metal, army-issue helmet," according to the *Summit Daily News*, was Sharon Garrison's nephew. As compensation, the family settled the outstanding mortgage that

Cody's mother had on her house and allowed her to live in it for the rest of her life rent-free.

Ghostly Tales tour visits the site where Cody was found. Using dowsing rods and EMF meters, the tour has had a sizable amount of activity in this area.

CHARLES WALKER APPEARS AGAIN

There are some families in Breckenridge that have been here forever and have contributed so much to the town's development. One of those families is the Daytons. Brothers Tom and Gene have lovingly built and nurtured the cross-country skiing industry in the town for over forty years.

In the early 1980s, Tom Dayton lived in the two-story log cabin on Lincoln Avenue that pioneer Charles Walker built. It is a great example of a gingerbread-style cabin, a real mountain home. While Tom and his family lived there, they experienced many strange incidents in the upstairs rooms. If they left an item in one place—say, on the bed—when they left the house, when they returned, they found it in the closet. If they left the same item on the dresser, when they returned, it might be under the bed. Things were being moved from one side of the room to another without anyone having gone near them. We know that Charles appeared to the forgers when it was time for his grave to be repaired (see "Breckenridge's Cemeteries"). Could it be that Charles Walker never passed over until 1997 when that event occurred?

Back in the 1970s, Gene Dayton, Tom's brother, and his family moved into a historic house in town, lovingly called the "Purple House." Gene remembers that his daughter had a regular visitor while she was there. An old man, wearing a red plaid shirt and dungarees, was often seen at the end of her bed. He appeared to be the original owner of the home, and he was now checking out the new owners. After several appearances, Gene's daughter thought it was time to have a word with him and politely told him that it was time to move on. She included him in her prayers too. He obliged, and she never saw him again.

Among psychics, parapsychologists and paranormal investigators, it is believed that ghosts who were extremely attached to their homes regard newcomers as intruders and will be curious to find out how the new occupiers are treating their former residences.

Tom's wife, AnnaDane, has had her fair share of spiritual experiences in her family also. It was her brother who stayed at the Prospector in 1976 and

saw the reflection of Sylvia in his bedroom mirror. During the popularity of spiritualism during the early 1900s, séances were common. Sir Arthur Conan Doyle started this religious interest in the other side, and it spread rapidly across the Victorian world. It wasn't unusual for people to try to contact their departed loved ones with the help of a medium in the privacy of their own home. AnnaDane's father was a non-believer in paranormal phenomena, and in his attempt to disprove the spiritualists, he organized a séance in his own home. In his commitment to disprove the existence of a spirit world, he went so far as to invite scientists to join the table, sitting in among the psychics. However, none of the guests were informed of the others' backgrounds. To her father's utter amazement and dismay, the séance was actually a success. The spirits were very active in making themselves known, and if that wasn't enough, the night came to a head when the table actually levitated a number of inches. Safe to say, her father never doubted the existence of the spirit world again.

CHAPTER 8

RAILROAD TALES

THE SPIRITS OF BOREAS PASS

Boreas was known as god of the north wind in Greek mythology, which makes it a very apt name for the high pass above Breckenridge where the wind rarely stops blowing. Originally a railroad line, it is now used by drivers as a scenic route to get to the near ghost town of Como and then on to Route 285 to Denver or Buena Vista.

The railroad arrived in Breckenridge in 1882, coming over the steep Boreas Pass from Denver. It was an important addition to link the towns in Summit County with the city and bring much-needed supplies. Before the arrival of the train, goods were hauled up in wagons, taking a week to get to Breckenridge. The Section House was built at the top of the pass in 1882 as a lodging facility for the section boss and railroad workers. They maintained the Boreas Pass section of the High Line Railroad, which started in Denver and took passengers and freight all the way to Dillon.

In 1898, Summit County experienced the worst winter the miners had ever seen. Snow started falling on Thanksgiving Day. It snowed five feet the first day and continued snowing every day right through to the end of February. Breckenridge was blockaded in, and the last train came over the pass on February 4, 1899. People in town then had no new supplies for seventy-nine days, until finally the tracks were cleared by locals who had had enough and skied or hiked up there with their shovels on their backs.

One man decided he couldn't wait for the railroad to be cleared. He was recently married to a young lady from Denver, but due to financial reasons, his bride had remained in Denver, living with her mother, until they could set up home themselves. Loren Waldo was a popular member of the community and had a good job in Breckenridge. He worked at a local hardware store as a salesman and bookkeeper, allowing him to save for their future. His job had been a busy one until the blockade had started. Now there were few customers to attend to and nothing left on the shelves to sell. The young man was anxious to start his married life, and with Valentine's Day approaching, he felt the separation from his new bride keenly. Within a week of the blockade starting, he had handed in his notice and was determined to make his way to Denver by whatever means he could. Two other men, one a railroad worker, had the same idea, and the three set off from Breckenridge on February 11, 1899, on their skis to get to Como and then on to Denver. They got to Boreas Pass safely, but even though Waldo was an experienced skier, he was tired after the steep climb and so took a rest. The other two men were so anxious to continue that they didn't want to wait for their companion, so they carried on. Waldo was encouraged to stay the night at the Section House, but he refused, and just as darkness was

Railroad to Boreas Pass. From *Victorian Goods and Merchandise,* by Carol Belanger Grafton.

falling, he set off once more. A blizzard set in, and he lost sight of the railway tracks he was following. He was not seen alive again.

His wife had received letters telling her that he wanted to return to Denver, but he never told her of his plan to make the journey on skis. If he had, she would have warned him not to do it as she was very intuitive and had recently had a foreboding about an accident involving her husband while traveling on skis.

Four months later, on a sunny day in June, a search party headed by Loren Waldo's father was scouring the area near Boreas Pass. In a patch of multicolored wildflowers, they found the body of the twenty-seven-year-old man, just a quarter mile from the railroad track. His body was in a good state of preservation. The inquest took place in Como, but finally his body was transported to Denver—his destination and his final resting place.

The Section House is still standing today and has been extensively renovated. These days, you can stay there overnight, as during the winter it is part of the Hut System for backpackers to Nordic ski or snowshoe to and then stay a night or two. A logbook sits on the desk in one of the reception rooms so that guests can sign in and tell about their experience while staying there. If you take time to read that logbook, you will discover stories of the spirits of the miners who still dwell there. There are many stories of a miner being seen by the overnight guests. He appears at the woodpile, dressed in overalls and carrying an ax. There are other mentions of apparitions of train passengers who are standing near the outside restroom while they wait for the next train. The logbook also contains stories of the train whistle that blows at night, followed by the sound of an approaching train. Finally, there are accounts of cracks and bangs and strange noises that assure everyone of a sleepless night.

A MOST UNFORTUNATE ACCIDENT

John Lasley was a railwayman in Dickey, Summit County, an important railroad stop linking Breckenridge and Frisco in the late 1800s. John had just finished his shift at work one day and was walking back along the track to get home when a terrible accident occurred. A railway car had accidentally been diverted onto the track on which he was walking, and despite shouts and warnings from fellow workers, he never heard them. The car ran him down, dragging his body with it until he was unrecognizable as a human being.

The coroner, Dr. Condon, along with other local gentlemen, was called to make up an inquest panel. The *Summit County Journal* of February 16, 1907, reported, "Upon their arrival at Dickey a most horrible sight presented itself. The body of John Lasley was literally ground into an unsightly mass, only the head bore semblance of what was once a strong, healthy man."

The verdict was accidental death.

If we are to believe that John Lasley is still with us in spirit following his appalling death, then he is to be found in the waters of Lake Dillon. The remains of the town of Dickey are now sited under the lake and disappeared from sight forever when the reservoir was created in 1963.

Unforeseen Obstacles

In 1898, there was a well-liked engineer who worked for the Denver, Leadville and Gunnison Railway. John U. Schmidt had lived in Como, Colorado, for four years, having moved there with his devoted wife and six young children. John loved his job and was a popular figure on the high line railway.

He was working on his favorite engine one day, leaving Leadville on its way to Denver. The train was passing the Curtin railroad stop when the firemen working on the engine realized that the train was approaching the station too fast and noticed that John was missing. When they got the engine to stop, they dismounted and went back along the tracks searching for him. About a half mile back, they found him by the rails. He was bleeding profusely and was barely breathing. They put him on the next train bound for Como, via Breckenridge, with the local doctor by his side. Alas, he never made it home alive. As no one had witnessed the accident, the coroner investigated the track where he had been found and put together his theory of what had happened.

Realizing that there was a fault with the engine, John had stepped out onto the running board of the engine to have a better look, not realizing that a cliff of rocks was approaching. As the train approached the curve of the rock cut, John was hit in the head and the impact brushed him off the engine. The result was that his right leg was broken, as well as his left shoulder, and his skull was crushed in.

He died on the top of the pass, at the Boreas station, without ever making it home. I am sure that his spirit joined the many others who already resided there.

CHAPTER 9
CHILDREN'S TALES

A DAUGHTER COMES BACK FROM THE DEAD

The only historic stone building in town was constructed in 1884, following the worst fire in Breckenridge history. It was originally a wooden hardware store owned and built by Charles Finding, an Englishman who came to seek his fortune in the mining town. He may very well have also come to "mine the miners," opening a store that catered to all the miners' needs. By all accounts, he was the only merchant who could afford to build his store from sandstone and mountain stone, which was brought up on the train from the Front Range. The store was probably financed in part by his numerous successful mining interests.

Charles married well by winning the hand of the catch of the town—Martha Silverthorn, who was the daughter of hotelier Marshall Silverthorn. Mr. Silverthorn also happened to be the only judge in town. Charles seemed to have it all—a thriving store, good mining investments, a showpiece home on Main Street and three lovely daughters. The only thing that could mar his happiness was the health of his daughters to whom he was devoted.

His middle daughter, Ada, had been an active and popular young girl, helping with charitable works just like her two sisters, but when she was twelve years old, she became very sick. She was visited by the doctor many times in early 1888, and although diphtheria was suspected, it was never confirmed. On a cold Thursday morning in January, the doctor visited

Finding building on Main Street. *Author's collection.*

one last time and told the distraught family that unfortunately there was nothing he could do for her, and it was unlikely that she would survive the day. Soon after he left, Ada stopped breathing. The family was devastated at the thought of losing their precious daughter. The doctor was called back and pronounced her dead. The death certificate claimed that the cause of death was unknown. Her body was then laid out in the parlor of their home, as was the custom back then, and the family went to the local newspaper to put her name in the obituary column for that day.

The following day a surprising event took place—she woke up! She was conscious for the rest of that day, but by the early hours of Saturday morning, she had passed away again, and so the doctor was recalled. He wrote out another death certificate, claiming again that it was a case of "cause unknown." She lay in the parlor for quite some time before the family was forced to bury her. They were very reluctant to bury their poor Ada but decided there was only one way they could deal with their sorrow. They had heard about safety coffins that had become popular in the Victorian era whereby a bell was attached to a chain or rope and connected to the coffin. If the deceased was not actually dead, they could pull on the chain from inside the coffin, and it would ring on the surface. At that point, the

gravedigger who was on duty could rescue the person and save them from being buried alive. Ada might not have been resurrected, but many people were, in fact, saved in that way.

Unfortunately, the luxurious home belonging to the Findings burned down in 1971, so the Ghostly Tales tour is unable visit this site, but it does stop at the original Finding store on Main Street. The orbs that have been captured in front of the building attest to the fact that there is some spirit activity there. Could it be the free spirit of Ada visiting her father at work?

THE ROBY GHOST

One of the earliest families to live in Breckenridge was the Robys. John Roby settled here in 1864 from Germany and made his living by starting up a store on the corner of Lincoln and Main Streets. He married into another of the long-standing families—the Remines. Minnie Remine Roby bore him six children, two girls and four boys. By 1883, they had grown out of the small cabin they lived in at the back of the store, and John bought a lot on nearby Ridge Street. He moved the cabin there and then expanded it so there was enough room for his growing family. Now the children had somewhere to play, and they flourished in their new home. Minnie Roby, just like Katie Briggle, regularly entertained in this house.

However, tragedy struck one day when one of the sons, Frank, had an unfortunate accident. He worked with his father at the store and delivered groceries all over the town. While out on his deliveries at the south end of town one day, the team of horses he was driving bolted. They had been spooked by the train's whistle as it came over Boreas Pass nearby. He steered them safely for a while until they were forced to cross a bridge. One of the wheels caught the edge of the wooden bridge rails, and the cart turned over, throwing Frank from his seat. He hit his head as he landed on rock and broke his neck, killing him instantly.

As the years rolled on, John Roby became sick, and they moved to a lower altitude to help his situation, but he returned to die in Breckenridge the following year, 1904. Minnie passed away in 1935, and the children grew up and moved out of town.

By the 1980s, their home had become a bed-and-breakfast. Many visitors passed through the building, enjoying their skiing and hiking vacations. However, there were reports to the owner of the inn of strange events

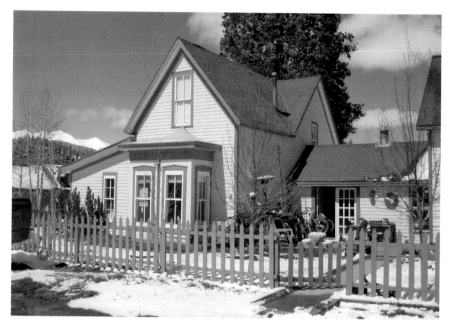

The Roby house, currently a private home. *Author's collection.*

happening in one of the bedrooms. One couple found themselves locked out of their room when they knew for sure they had left it open, and others noticed cold spots in the room, even in the summer. One female guest reported that there was a young girl who appeared to inhabit her room. This guest admitted to being psychic and stated that the unhappy ghost was a female around ten years old and was constantly crying. For the sake of a good night's rest, she asked to be moved to a different room. She also reported seeing many children playing happily outside in the yard. A local resident, Sheila Jagentenfl, was a friend of the owner during this time and visited her regularly. She claimed that the girl was not friendly and didn't want anyone staying in "her" room.

By the early years of the millennium, the inn had been turned into small apartments and was put up for sale. It was eventually sold to new owners. This couple had looked everywhere for a place to call home, and as soon as they saw the Roby house, they fell in love with it. This felt like just the right place to move in with their newborn daughter and settle down to family life. They had to do quite a lot of remodeling to get it back to a single-family house, but now it feels just like home. The unhappy girl has never been seen or felt since they moved in.

TRAGIC DEATH OF SUMMIT STEPHENSON

Summit Stephenson. From *Victorian Goods and Merchandise*, by Carol Belanger Grafton.

Most boys born back in the early 1900s were given the name of George, William or Edward, but occasionally someone broke away from the trend and came up with an original name. A local boy by the name of Summit was playing with his friend in the back garden of his house. The boys had plenty of time on their hands and wanted to practice their high jumping skills. They didn't have the correct poles, so they improvised by balancing a broomstick on two rocks and then commenced practicing their high kicks. When it was Summit's turn, he took a run at it and lifted his leg to jump over but caught it on the stick instead. The end of the broomstick handle happened to be broken and very sharp, and somehow he had managed to tip it up on end as he jumped. Unbelievably, he impaled himself on the handle. As it penetrated his abdomen, it lacerated his bladder. Surgery was needed, and Dr. Scott, a local doctor, told the family that the surgery was very delicate and he needed a Denver surgeon to attend. He sent word down to the city, and the surgeon got on the earliest train to Breckenridge. Regrettably, Summit deteriorated rapidly during the night. He hung on by a thread until 3:00 a.m., when he succumbed to his injuries. Just two hours later, the morning train arrived, bringing the surgeon.

THE DANGERS OF KEEPING HOUSE

In Victorian times, keeping house was a serious business. Cooking, cleaning and looking after your children had to be learned and practiced. Cleaning your house was high on the list of priorities for housewives, and they took great pains to get it right. Of course, they used very different products than the ones we use today. Some were very safe to use, but others were downright dangerous.

One bright spring morning, a local lady named Mrs. Cummings decided to take advantage of the warm weather and took a walk to visit a friend of hers. She took her young son, Carl, along with her. When she arrived at the home of Mrs. Miller, she found her friend scrubbing her floor, and the two ladies were soon deep in conversation about the merits of the different cleaning materials they used. They were so engrossed that they didn't notice Carl pick up the tin of lye soap that was on the floor. Lye is an extremely corrosive substance that scars and causes chemical burns immediately upon contact. They were completely oblivious to the fact that he had poured the contents of the tin onto the floor. Not until he was playing in it and rubbing it on his face and mouth did they turn and look his way. Horrified, Mrs. Cummings picked her son up and washed him down as fast as she could. The little one was badly burned on his face and hands. Carl survived but was terribly scarred for the rest of his life.

You would think that bathing your child would be a safe task but not always. Jane was a former schoolteacher from the nearby mountain town of Montezuma who was now happily married with a fifteen-month-old son and had settled in Breckenridge. It was time for her son's weekly bath, and Jane brought out the tin bath from the closet and placed it in the middle of the living room. She turned to take the kettle of boiling water from the stove and emptied it into the bath for him. She turned around again to refill it with cold water to add to the tub when she heard a loud scream. As she turned back, she saw that her toddler had jumped straight into the boiling water. She watched in shock as he cried and yelled, but there was nothing she could do to save him. He lived just a few hours longer but then died from the burns that covered his poor young body.

CHAPTER 10

BITS AND PIECES

THE ECLIPSE THEATRE

The building that sits at 121 South Main Street, originally situated seventy-five feet to the south of its present location, has been many businesses over the years. Moving buildings one hundred years ago was quite commonplace in this town. None of the timber-built businesses or houses were given foundations, and so it was easy to transport the buildings by putting long pieces of timber underneath them and dragging them to new locations. This was always done in the winter so the horses could pull them across the icy roads.

Built in the 1880s, the building started its life as Captain Turk's pharmacy. By 1910, this address was a theater called the Eclipse Theatre, showing moving pictures. Entertainment was a welcome break in the mining camps, and this town was no exception. There was also one of the finest saloons around at the rear of the building called the Gold Rooms, its walls lined with gold-colored wallpaper.

By the 1960s, it had become a pharmacy again and was owned by Breckenridge Lands, a local development company. Rick Bly took it over about ten years later and eventually bought it from the company in 1985. To help with running costs, he always rented out the apartment above. A young woman by the name of Brodie rented it one winter. She lived there with her cat, Blackie, but noticed that he became very agitated soon after they

moved in. He continuously stared at something moving around in the room with the same intensity that he used to stalk a housefly. Brodie wasn't the kind of woman who was disturbed easily, but she told Rick that she couldn't understand why the cat regularly growled at whatever it was that was lurking in the corner of the room. It became too much for her to handle, and so before the end of her lease, she had moved out.

Jan from Creatures Great and Small gift shop lived here in the 1980s in the apartment upstairs. She thought it was a great location, as she was so close to where she worked on Main Street. Soon after she moved in, she started to hear footsteps. She didn't think too much of it as she was so close to the old building next door at 123 South Main that she felt sure it was someone moving around in there. One morning, however, she walked into her living room and was amazed to see a footprint in her living room area. In the middle of the carpet was one huge, muddy footprint. At the same time, she noticed a glass on the coffee table that had contained orange juice the night before. It was still standing upright, but the orange juice had spilt all over the table. She never got to the bottom of the mystery, but to her the location was too good to miss, so she didn't let that incident upset her.

After Jan left to get married and start her own business, Rick rented it to a guy called Jim who had spent time in prison. Rick wanted to help him out, as he felt that Jim was down on his luck. He also felt a sense of overpowering sadness attached to this man. One morning, Rick was working in his store below and training a new assistant. It was a very cold winter's day—about fifteen degrees below zero—when suddenly the front door opened, and Jim ran in wearing only his underwear. He seemed very distressed and couldn't stop shaking. Rick took his own coat, and covering Jim with it, he helped him to a chair. He sat there for almost an hour before he was able to speak and tell what had happened upstairs.

Jim had been in his bathroom, a tiny room only big enough for one person. As he lifted his head to look into the mirror above to start shaving, he saw a figure behind him. This figure was male, had a long beard and was wearing a Kipa (yarmulke). In fact, he was dressed just like a rabbi. That was when Jim fled his apartment to tell someone about his vision. Jim was very troubled by this incident, but having nowhere else to go, he stayed in the apartment with the ghost for many more years.

Back in the late 1800s, the store to the south of the Eclipse was Levy's dry goods store and was owned by Mr. Charles Levy, a rabbi.

It transpired that Jim had led a very sad life. When he was still at college, he was walking home with his girlfriend one evening after attending

The Eclipse Theatre on Main Street, currently a jewelers. *Author's collection.*

a party. One of the other partygoers got in his car and was driving down the same road. Stopping to say hi to the couple, the driver suddenly veered onto the sidewalk and hit Jim's girlfriend, killing her outright. A few years later, Jim and a friend of his had been camping for the weekend and were returning to Breckenridge on Sunday evening. It was very late, and Jim started to fall asleep at the wheel. They were just about at the Wheelers Flats area near Copper Mountain when Jim swerved across the road, crossing the median, and crashed head on into an oncoming car. The female passenger in the car was killed instantly. Jim never got over the sadness he had caused, reliving the agonizing time he had gone through when his girlfriend had been killed in a similar manner. He felt the terrible pain the family was going through.

It is believed in the paranormal world that if a person's emotions are down and their energy level is very low, they are more susceptible to making contact with the spirit world—or rather, that the spirit world will make contact with them.

There has been a constant change of tenant upstairs ever since Jim stayed there. Could it be that Jim woke up the spirit of Levy?

Hitchhikers Who Never Reached Home

The winters in Summit County are long and cold with snowfall amounts differing vastly from one year to the next. An average snowfall year will yield about three hundred inches, but it can get to as low as eighty-two inches,

which was the case in the winter of 1980–81. It was a very disappointing season for the ski areas. The following year made up for the shortfall and yielded above average levels. Additionally, Summit also encountered some of the lowest temperatures on record for that season.

On January 6, 1982, the low was twenty degrees below zero, but earlier in the evening, it had been just a few degrees below when a young woman was hitchhiking her way home from Breckenridge, where she worked, to Alma, where she lived with her husband. Bobbi Jo Oberholtzer worked at a local development company and had received a promotion that day. She met a girlfriend at a bar for a drink, and she stayed a little longer than she had planned to celebrate her good fortune. Her friend's boyfriend arrived to join them and offered to give Bobbie Jo a ride home. However, he was in no hurry to leave, and Bobby Jo was getting tired and hungry, so she left the bar to walk to a popular hitchhiking street corner on Highway 9, where she had stood to wait for a ride many times before. Despite the freezing temperature and very few cars on the road, she didn't have to wait long for a lift. Tragically, she never reached her home in Alma, just a thirty-minute ride away, over in neighboring Park County.

When her husband reported her missing early the next morning, a search party was formed. It didn't take them long to find her. On the morning of January 7, she was found near the top of the pass, in a huge snow bank at the side of the highway. She had been shot twice and left for dead.

Earlier in the day on January 6, another hitchhiker had taken the same route to get home. She also picked up a ride on Highway 9 and was trying to reach her home in Blue River, just outside Breckenridge. Annette Schnee had two jobs—in the daytime, she worked at the Holiday Inn in Frisco, and her evening job was as a bartender at the Flipside Bar, part of the Beaver Run complex in Breckenridge. She had been sick for a few days, so stopped off in Breckenridge to fill a prescription before getting back onto the highway to continue her journey to Blue River. Just like Bobbi Jo, she never reached home. She wasn't found immediately though. It took six months for her body to be found in a watery ditch several miles south of Breckenridge. She had been shot in the back and left for dead.

The only clue that linked the girls was a bright orange sock that was found near Bobbi Jo's body. The matching orange sock was found on Annette's body. The possessions of both girls were scattered alongside the highway between the top of Hoosier Pass and the road that led to Denver, several miles south of Fairplay. These murders shook Summit County to the core, but despite many witnesses coming forward, no one was ever brought to trial

and therefore no one was ever convicted of their murders. Psychics have been brought in to help the police in their search but with no conclusion.

In the 1990s, two young men rented the house where Annette was living when she was murdered. They expected a quiet life living out in the seclusion of Blue River, but that was not to be. As soon as they moved into the house, they started hearing strange noises. That was followed by chairs moving across the floor by themselves and cold spots constantly emerging from nowhere. The strangest thing of all was the footsteps that appeared in the snow outside, just below the windows of the house. These footsteps had no beginning but led straight to the house and didn't return. It was as if someone had been lowered down out of the sky and then picked back up again. Do these footsteps belong to Annette, as she tries desperately to get back into her home?

Today, the only remains to be seen of the murdered girls are the two crosses to mark the sites where they were found—a reminder of the two hitchhikers whose lives ended so tragically.

The cold case is still open and being investigated. Any readers who may have any information to pass on are encouraged to reach out to the Colorado Bureau of Investigation.

"Hitchhiking" is also a term used by people in the paranormal world to describe a spirit that attaches itself to people when they are visiting a haunted site. It is a rare occurrence but not unknown. The spirit will usually only attach to someone who is very sensitive.

In recent times, another employee of Beaver Run, where Annette worked, found out to her horror that she had picked up a spirit hitchhiker while at work one day. This female hitchhiker followed the employee, Nancy,* home and stayed at her house for several months. At first, Nancy thought she might be an angel—she felt that it was a kindly spirit—but as time wore on, she realized that that was not the case. This spirit was sucking the life out of her. Nancy found that even if she slept at night for eight hours solid, she still woke up tired out and had no energy whatsoever. She decided it was time this hitchhiker moved on, and one day she yelled at the spirit to leave the house. She was in her kitchen at the time and about to start making dinner. She reached into one of the cabinets for a dish, and just at that moment, a glass measuring jug flew out from a shelf above, smashing on the countertop and stabbing her in the hand. Nancy was bandaged up for a week after that. Enough was enough, she thought.

* Name has been changed to protect the contributor.

Visiting Denver for a book signing shortly after this event was a psychic by the name of Mary Ann Winkowski, who developed the show *The Ghost Whisperer*. Nancy was determined to go down and see her to get some advice. She was all ready to go to her car when she realized that the door to her garage was jammed. It wasn't locked, but it wouldn't budge. Some force was stopping her. That's when she ran out of patience and screamed out, "Leave this house right now!" Thankfully, Nancy was able to meet up with Mary Ann, who helped her get rid of her unwanted guest.

Nancy still enjoys her job, especially helping to prepare the conference rooms when they have a memorial service booked. She makes sure the room is laid out properly and the photos of the deceased are displayed well. One day she was working at her desk when she saw the apparition of a tall, dark-haired man in her office, and being used to the ability of seeing ghosts, she wasn't perturbed. She guessed it was the deceased man whose memorial service was taking place that day, but when she studied the photograph of him, she realized it couldn't be him—the man in the photograph was blond, and the apparition was dark. A few days later, she was again getting the conference room ready for that day's memorial service when she looked at the photograph of the recently departed man and was taken aback when she realized that she was staring at a picture of the dark-haired male apparition she had seen in her office just days before.

OUT OF BRECKENRIDGE

DILLON: THE LADIES OF THE LAKE

When building foundations are laid down and towns created, it is a reasonable assumption that that location is where a town will stay. However, this is not the case with the town of Dillon. In fact, the town of Dillon has been moved many times. It started its life as a rendezvous point for trappers and became known as "La Bonte's Hole." It lay in an idyllic site where three rivers met—Blue River, Snake River and Ten Mile Creek. Travelers and prospectors made frequent stops in this area on their way to the gold mining camps. By the 1870s, it was a popular stage stop. When rumors started that there was going to be a train stop here, the Dillon Mining Company, which owned 320 acres of land there near the Snake River, moved the township to near the Blue River instead so it could be close to the railway line. The company moved it again shortly after to be on the west side of Ten Mile Creek, where the train depot was eventually built. The townspeople really liked this new location, and they decided to stay put. Unfortunately for them, it was not to be.

By now Denver was growing at a fast rate, and the city couldn't keep up with its citizens' need for water. The Denver Water Board started making plans to alleviate that problem by buying up land in Dillon with an idea to build a dam. The board started warning the residents that their town would disappear in 1956, and when everything was ready to start building the dam,

the Denver Water Board sent out announcements to the Dillon residents and told them that they had to evacuate by April 1, 1961. The townspeople were devastated, and those who had the resources moved their homes, stores and businesses to surrounding Frisco, Breckenridge and new Dillon. Some large structures, such as the school, were demolished, and any buildings that weren't claimed by the deadline were burned to the ground.

One of the hardest tasks of all was moving Dillon's cemetery, the only cemetery that was ever patented. Through the Cemetery and Park Act, this site was listed as a subdivision and granted by President McKinley in 1901. Apart from the obvious problems with moving the graves and notifying the relatives to gain permission, workers heard rumors of the threat of plague coming out of the plots and didn't want any part of it. A new cemetery site had to be designated, and this time it was way up on a hillside outside the new town. Eventually, all the graves that could be moved found a new home.

Life moved on for Dillon residents, and they adapted to their new location. By the 1970s, this was a popular boating lake, and all outdoor sports were being enjoyed—sailing, biking, fishing and hiking. However, a tragic accident happened on the lake in the summer of 1977. In the August 4, 1977 edition of the *Summit County Journal*, an unusual headline appeared: "SUBMARINE ABANDONS SEARCH FOR SAILBOAT."

A few days earlier, ten friends, mostly from Denver, gathered together to have fun on the lake and rented a twenty-two-foot sailboat. The day had started out sunny and warm, with a fresh fifteen-mile-per-hour wind, but as the day wore on, it became windier, and an unexpected squall hit the county. One particularly strong gust hit the sailboat and capsized it. At that point, eight of the friends were on the deck, and two ladies in the group were down in the cabin. No one had a chance to release the ropes that were securely cleated. The keel was not fully pushed down to stop the boat tipping over. All those on deck were swept over into the thirty-degree water below. Fortunately, many people ashore had seen the boat capsize and immediately set out to rescue those who were floundering in the water. The irony was that the sailboat had gone down directly opposite the Dillon Marina, just 1,600 feet away from safety. The two women were trapped. One woman who tried to swim to the surface got tied up in the ropes that were flaying around and, in fear, returned to the safety of the air pocket she had in the cabin. As the rescuers tried to right the boat, the air pocket was lost and the boat sank shortly afterward in eighty-five feet of water.

Sailing on Lake Dillon. *Author's collection.*

Coincidentally, the accident happened right over the location of the original Dillon cemetery.

Divers from the Littleton Fire Department started the search for the sunken boat but had no luck. By coincidence, the husband of one of the women who was missing, Joseph Wagner, owned an industrial equipment company in Denver and hired Colorado Divers to take over from the volunteers. They searched for four days, until they were exhausted in the icy water but found nothing. At the same time, a local from Aurora who happened to own a submersible craft offered his services and helped the rescue effort but had to abandon his search because of poor visibility. Mr. Wagner also supplied sonar equipment to locate the boat—all to no avail. The local sheriff requested the navy assist with the Summit County Search and Rescue team, and it was the navy that finally had success when an underwater TV camera was put into the lake eleven days after the accident. Soon after the boat was spotted, workers were able to bring one of the bodies up, and when they moved the sailboat into shallow water the following day, they were able to extract the second victim.

Today, there are many people—locals included—who like to tell the story of the sunken town under the lake. They say that the tops of the buildings appear at low water and that you can even see the spire of the church. Now you know the true story.

FRISCO: OPHIR LODGE

In 1910, a family came to Frisco to homestead and was granted a Deed of Trust signed by President Taft for 145 acres of ranch land. Jane Thomas was the recipient, a tiny Welsh woman only five feet tall but with the strength of an ox. When she passed away, it was handed down to her two sons, Bill and Walter. The dairy ranch was worked by Bill and Walter for many more years. Jane also bought the Leyner Hotel on Main Street in Frisco for $33.32 in 1887 and called it the Thomas Hotel. This was later dismantled, and one side of the hotel was moved to the ranch site as a home. Later still it became a lodge that still sits in Bill's Ranch today.

There were very few residents during the 1920s, so Bill Thomas came up with an unusual idea to entice new residents to the area and promote business for his dairy products. He sent out a letter in the *Denver Post* offering free cabin sites to anyone who would settle in Frisco. He gave away the first five cabin sites and even helped the new residents build the cabins. After that, the sites were sold for half a cent per acre, and the crowds arrived.

Bill died in 1952 and is buried in Frisco in the family fenced plot near the marina. The ranch was sold several times and the lodge on the ranch eventually ended up in the ownership of Ben Little and his sister Marsha. The new owners added on an extension in 1996, and it was at that time that they started to notice activity in the building.

The haunting at Ophir Lodge, as it is now known, started with cold spots that were felt by guests upstairs in the bedrooms. Following that, the figure of an unknown woman was seen in the kitchen. At the same time, a child was heard crying upstairs. When an electrician was called in to do some repairs one day in the basement, he found that he was sharing the room with the apparition of an old man. He felt sure he was being checked for his workmanship. This figure has also been seen by the owner, Marsha, who states that he is not threatening, just watchful.

This beautifully restored lodge is currently open to the public for wedding rentals, retreats or other special occasions, so if you would like to meet the

deceased residents, you have your opportunity. (For more about Bill, please
see the Minnie Thomas story.)

Keystone, Montezuma, Sts. John: The Busy Loggers

If you drive out of Silverthorne on Highway 6, you will enter the White
River National Forest Valley. If you keep climbing that road, you will pass
Keystone and Arapahoe Basin and reach the Continental Divide at the
peak. After leaving Keystone, you can choose to make a right turn onto
Montezuma Road, which will take you to the town of Montezuma, and if
you continue on that road, you will pass a sign for the ghost town of Sts.
John. Now you will have reached the area of the silver mining capitals of
the late 1800s.

Sts. John was famous for having the first silver strike in Colorado in 1863.
Its other claim to fame includes having the first smelter, built with bricks
that came all the way from Wales in the United Kingdom. Not surprisingly,
most of the miners were from Wales also. They were very upright citizens
and ate from china plates instead of the usual tin. They built a library to
entertain themselves after work, and if any of the single men were in need of
an alcoholic drink or desired the companionship of a female, then he would
have to walk the three miles down to Montezuma to find it.

Montezuma, named after the Inca tribe of South America for the riches
found in the area, was more of a typical mining camp of the day. It had its
own newspaper, streets, saloons, stores and, of course, a red-light district.
Every direction you looked were silver mines, which made the town a
fortune up until the silver crash of 1893. It had five major fires since it was
established (the last was in 1963) but is still inhabited today.

The town of Keystone was very small and was significant for a different
reason—the railroad. The old Keystone railroad stop was hugely important
for receiving the ore from silver mining towns like Montezuma, Chihuahua
and Sts. John and then transporting the lodes down to Denver in freight cars.
In fact, the only lasting rail depot in Summit County today is that of old
Keystone, still standing in its initial location. Old Keystone also had its own
sawmill, which was kept busy by making railroad ties from the local forests.
The sawmill provided a lot of employment for this town.

Many of the well-built log cabins from the above towns have survived to
present day and are even still habitable. A friend of mine recently started

to occupy one of those cabins and found to her surprise that she wasn't alone. Immediately after she moved in, she noticed that she could hear the sound of hammering. At first she thought it was coming from the roof, but when she listened more closely, she found that the sound was all around her. Wondering whether she was imagining things, she talked of it to a friend of hers living in a neighboring cabin and found that her friend was also aware of the noise. Both girls were perturbed by this activity but did not have the option of living elsewhere, so they decided to take the matter seriously. Voicing their disapproval of the goings on around their cabins, they firmly asked the ghost to quit making its loud hammering and to leave them alone. They believe their efforts were successful, as it has definitely quieted down around them.

All of these cabins were close to sawmills and mining works. Loggers worked all day in the mining era to erect cabins for shelter. Hammering would have been a constant noise in these areas, sometimes day and night.

In another historic cabin not too far away from there, Jake and Kelly shared a cabin. They were friends and each had their own room in the cabin. One night, they both heard a pounding on the roof, followed by Jake's door (which led outside) slamming open and the light in his room being flicked on. They were at a loss to guess what had occurred. The following night, Jake was lying in bed fast asleep when he awoke suddenly to find himself staring at something hanging over his bed. It was a dark shadow, the size of a pillow, and it was hovering over his face. He thought he was dreaming so, he turned over to go back to sleep. When that incident was repeated on another night, he started to wonder what was going on. He thought long and hard about it

The Busy Loggers. From *Victorian Goods and Merchandise,* by Carol Belanger Grafton.

but still came to the conclusion that he had been dreaming. However, when he woke one night to find the brightest light he had ever seen before right there in his room, he couldn't explain it away. It wasn't there for just a few minutes—it lasted over four hours. That's when he remembered an incident that happened to him when he was younger, and he concluded that he must have the gift of sensitivity.

When Jake was a freshman at college, he got news one day that his grandmother had sadly passed away. Having his finals to study for that week, he knew he couldn't possibly make it to the funeral. He was really disappointed to have missed it, as he had been very close to his grandmother—so close that he had a nickname for her: "Shorty." Just before going to bed that night, he went to the window, which was covered in condensation, and he wrote her name in large letters across it. When he woke up the following morning, the name had disappeared. In its place, two angel wings had been drawn on the window.

Jake has since moved out of that cabin and found a quieter location, where he can hopefully get some sleep.

ABOUT THE AUTHOR

 ail Westwood was born in England and immigrated to the United States in 1999 with her husband and two daughters. After many previous careers, she became a historic walking tour guide, following her fascination with the history of the Wild West. She wrote and developed a ghost tour of Breckenridge in 2010 and now owns and operates Breckenridge Tours. With her trusty friend Jamie, they now entertain visitors to the town with their Ghostly Tales tour and living history tours. Gail is a member of the Summit Historical Society and a volunteer archivist. She loves to cross-country ski, play tennis, dance and go on all the ghost tours she can find around the country.